DATE DUE			
DEC 2 2 1983		APR 8 2000	
NOV 8 '84			
APR 1 6 1985			
MAY 1 7 1985			
DEC 1 2 1991			
FEB 1 0 1995			

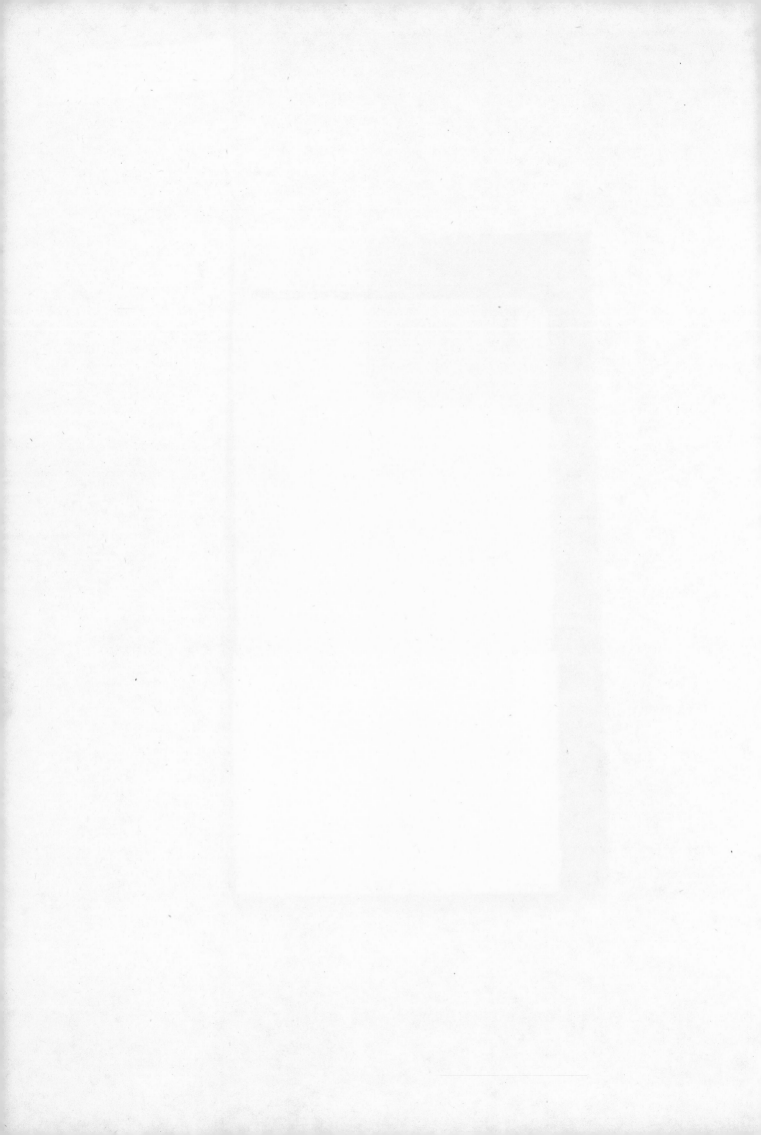

Richard Shone

SISLEY

PHAIDON

D.G. 1885–1978

Phaidon Press Limited, Littlegate House, St Ebbe's Street, Oxford

Published in the United States of America by E. P. Dutton, New York

First published 1979

ISBN 0 7148 1962 X
Library of Congress Catalog Card Number: 78-24661

Printed in Great Britain by Morrison & Gibb Ltd, Edinburgh.

SISLEY

The Chinese painter Kuo Hsi, who worked in the eleventh century, left a treatise on landscape painting in which he wrote of the themes and subjects suitable for a painter: 'There are four seasons, and each season in its turn has a beginning and an end. The morning and the evening, the moods of objects and the colours of things must all be analysed. Moreover, each has its characteristic mood.' He goes through the seasons listing their possible subjects – spring clouds clearing after rain and the last of winter snow; morning walks through summer fields and afternoons of blue sky and cumulus clouds; autumn mists and west winds bringing rain; winter gloom heavy with snow, chilly clouds and snowy paths. He takes pleasure in misty streams, snow at dawn, autumn haze in the evenings. Reading of these we enter Sisley's world, for they were his constant subjects in a career devoted almost entirely to landscape. We must exchange, however, the mountains and cascades of Kuo Hsi's China for the less dramatic topography of the Île-de-France, of those 'heroic centres of Impressionism' – Louveciennes, Marly, Argenteuil, Bougival; and the expansive flow of the rivers Seine and Loing take the place of rushing torrents and waterfalls.

The subtlety and quiet variety of the landscape in which Sisley passed most of his working life are embodied in paintings which, while immensely varied in quality, consistently express his deep attachment to that area. He rarely left it (there were three visits to England) and never went south; next to Pissarro he was the least travelled of the original Impressionist group. Early on he seems to have reached a very clear idea of his preferences and limitations, and although new types of subject occur in his work (and others disappear), the essential impulse to explore effects of atmosphere, light and mood remains. He did not have the restless intellect of Pissarro or the grand ambition of Monet, the two painters with whom he has most affinities among the Impressionists. Surveyed as a whole, his work is on a smaller scale than theirs, but he did produce individual paintings which must be among the finest of nineteenth-century landscapes and which made a definite contribution to the Impressionist movement. His perfection of tone, sureness of composition and variety of handling are in perfect accord with a sensibility that was frank, tender and transparently sincere.

There is a painting by Renoir – his first large figure-composition – which shows a group of friends being waited on at table in a country inn (*Le Cabaret de la Mère Anthony*, 1866, Nationalmuseum, Stockholm). In the foreground is a young, bearded man, well dressed, a newspaper in front of him, who has his head turned away from the spectator. It is Alfred Sisley, Renoir's close friend and painting companion at this time. Turned away from us, Sisley's attitude might be taken as representative of his shadowy presence among the Impressionists, for he is the least known of them. Monet and Renoir are immensely well documented as people, particularly from eye-witness accounts, from letters and photographs and the finds of innumerable researchers. Pissarro was a prolific letter-writer and many fugitive details of his life and working habits have come down to us. But with Sisley we come again and again to a full stop – very few letters and documents, two or three photographs, one statement about his painting, and several years about which we know nothing beyond his place of residence. A few, often-repeated facts have frequently been found incorrect on later examination and contemporary descriptions of him are rare. This lack of knowledge is partly explained by his retiring character, which became more so

with the years until towards the end of his life he rarely stirred from Moret-sur-Loing, the small country town where he died. Since then he has never been an unpopular painter but he has suffered critical neglect, too easily dismissed as a poetic charmer with a nice line in snow-scenes and floods. On another level too his work is inaccessible – you cannot buy a postcard of any of his works in the Jeu de Paume, and in a recent, lavishly illustrated French history of Impressionism he is assigned just three reproductions. But then Sisley was English.

William Sisley (1799–1870) was a prosperous businessman dealing in textiles, initially based in London's Watling Street behind St Paul's Cathedral, but spending much of his life in Paris. His wife Felicia Sell (who was also his cousin) was the daughter of a saddler from Lydd in Kent. William and Felicia Sisley were both descended from successful smugglers and tradesmen, equally at home in France or England, where they lived in Romney Marsh, an area of Kent well known for its smuggling traffic with the Continent. As one of Sisley's relations later wrote, 'the character of his art seems to suggest an origin in French bourgeois culture rather than in rugged, English peasantry'. Alfred Sisley, who was born in Paris on 30 October 1839, had one elder brother and two younger sisters, Aline and Emily – significantly one French and one English name. Almost nothing is known of Sisley's life until he was twenty-two; we can be sure, however, that it was comfortable and not without some cultural stimulation, for Mme Sisley apparently had musical and literary tastes, both inherited by Alfred. In 1857 he was sent to London for four years to prepare for a commercial career in his father's business, but we are told he preferred visiting exhibitions and looking enthusiastically at Constable and Turner. He may well have seen work by French artists on view in London and also by the Pre-Raphaelites. Corot and some of the Barbizon painters were beginning to be seen frequently in London, and Sisley could well have had a foretaste of the French landscapists who were to influence him profoundly after his return to Paris. Shortly before his twenty-third birthday in 1862 Sisley entered the studio of Charles Gleyre, having persuaded his parents to allow him to study painting and abandon commerce.

Charles Gleyre (1806–74), a burly Swiss with a strong German accent, taught at the Ecole des Beaux-Arts, but had opened a studio, as did other teachers from the Ecole, to counteract the unsettling system there 'where teaching was done in rotation by the different masters without any real consistency of method'. Remembering early years of poverty in Paris, Gleyre waved aside teaching fees for his students; about thirty or forty of them attended his atelier in the rue Vaugirard. Although Gleyre was certainly no innovator and partook of much current academic doctrine, he deserves more sympathetic attention as a teacher than has usually been given him. He was an infrequent exhibitor, a reserved, introspective man, conscious perhaps of a sense of failure in his later years and troubled by increasingly poor eyesight. He could be encouraging to his students and certainly gained their affectionate respect for his independent views and generally tolerant attitude. Like Manet's teacher Couture, he encouraged study out of doors and painted landscape himself, but felt it was hardly the proper subject on which to base a career. It is ironic that among his students were Monet and Sisley, both outstanding practitioners of landscape in its purest form.

Gleyre's atelier is amusingly evoked in Du Maurier's novel *Trilby*; the range of students was wide, running from rich young dilettantes to a freckled English girl who was all for free love and Courbet. Whistler had been a student there in the mid-fifties and acknowledged his debt to Gleyre's teaching, particularly on the preparation of the palette, on which Gleyre recommended that all tones necessary for the proposed work should be assembled, thereby facilitating quick and spontaneous painting. In 1862 four

remarkable students entered the atelier – Monet, Bazille, Renoir and Sisley, the two latter also attending courses at the Ecole des Beaux-Arts. Monet was perhaps the least receptive to Gleyre's teaching; Bazille went to the atelier in the mornings and the Ecole de Médecine in the afternoons; Renoir worked industriously – 'under Gleyre I learnt my trade as a painter', he said later. All became Sisley's intimate friends – particularly Renoir – and were in close accord through the following years.

Of Sisley's student work nothing survives. His development during the 1860s must be deduced from a handful of pictures only. Certainly the example of Corot and Courbet meant much to him; he was perhaps introduced by Monet to the work of Boudin and Jongkind though, unlike Monet, his essentially conservative nature prevented any quick assimilation of those two painters. It was to Corot that he returned again and again, and in Sisley's one pronouncement on his painting method and attitude to landscape (in a letter to Adolphe Tavernier of 1893) he comes close to Corot's notes on his own work, even to the point where both agree to painting the sky first and to the initial importance of establishing as simply as possible the work's construction, the formal point of departure. Then the whole should be enveloped in a consistent atmosphere. Similar motifs excited Corot and Sisley – the edge of woods, or woodland clearings; roads and avenues leading towards the horizon; village corners; small anonymous figures walking or at some country pursuit, which give a sense of scale and intimacy to a landscape; or clusters of buildings by a river, viewed often through trees from the opposite bank (best seen in Corot in his late paintings of Mantes, contemporary with Sisley's early works). All these subjects were pursued and refined in later years, amplified by Sisley's increasing preoccupation with water and with aspects of weather not treated by Corot, such as frost and snow. But already we can see in such a painting as his Salon exhibit of 1868, *Avenue of Chestnut-trees* (Southampton Art Gallery), the subdued browns and heightened greens reminiscent of Courbet, more personally developed in the *View of Montmartre* (Plate 3) of the following year. A further influence may be detected in a painting unusual in Sisley's œuvre, a still-life, *The Heron* (Plate 2), in which the subtle blacks, greys and dusty mauves put one in mind of Manet's distinctive colour preferences. The sureness of tone Sisley achieved here rarely deserted him.

Renoir is the only witness to Sisley's character at this period, although his name appears often in the letters of Bazille, Monet and their friends. Gleyre closed his school in 1864 and thereafter Sisley was often in Paris, and at Chailly and Marlotte in the Forest of Fontainebleau. Unlike Renoir and Monet he was financially secure, having a generous allowance from his father, whose business at that time was expanding and prosperous. Sisley was known for the gentleness of his disposition, his quiet good manners and the gaiety of his humour. 'He was a delightful human being', Renoir later told his son Jean. 'He could never resist a petticoat. We would be walking along the street, talking about the weather or something equally trivial, and suddenly Sisley would disappear. Then I would discover him at his old game of flirting.' That Sisley did not have to earn his living by painting may explain the small number of pictures we have by him up to 1870. It also partly accounts for his marriage in 1866 to a young Parisienne, Marie Lescouezec (1840–98), who, according to Renoir, 'had a very sensitive nature and was exceedingly well bred. She had taken up posing because her family had been ruined in some financial venture.' The Sisleys had two children – Pierre, born in the spring of the following year, and a girl, Jeanne – both of whom appear in *The Lesson* (Plate 1). Two years after their marriage Renoir painted the celebrated *Portrait of Sisley and his Wife* (Cologne, Wallraf-Richartz Museum) which gives some idea of Sisley's tender and solicitous regard for his wife. It seems likely that some of the more closely observed figures of women in Sisley's

landscapes were posed by her, *Woman Resting by a Stream* (Plate 37) being one example.

In the year of his marriage Sisley had two pictures hung at the Paris Salon–both Fontainebleau landscapes–but in the following year, along with Renoir, Pissarro and Bazille, he was refused. They vainly petitioned for a new *Salon des Refusés* on the lines of the one held in 1863, where Manet's *Le Déjeuner sur l'Herbe* had outraged the public, and discussions began on the possibility of holding their own exhibition. In 1868 the painters secured an ally on the Salon jury in Charles Daubigny, associated with Barbizon but then living at Auvers-sur-Oise; through his stubborn advocacy, the future Impressionists were accepted.

In 1870 Sisley began the great decade of his painting. His progress was astonishing. In a few months we move from the compact, linear *View of Montmartre* (Plate 3), essentially pre-Impressionist, to the two views of the Canal Saint-Martin in Paris (Plates 4 and 5). The subjects are urban, with workmen unloading barges, and characteristic Paris houses in the background; in *The Barges* a chimney in the centre echoes the tall masts to the left. The verdant greens of Fontainebleau have been replaced by wintry trees and a distinctly chilly air. Above all, there is a new freedom in the handling of the paint, brushstrokes are more tentative, much less smoothly merged, and various areas of the canvas are differently treated to give a surface that is animated yet held together by the prevailing light. This differentiated brushstroke – flurried and brief on the water, smoothly parallel on the barges – has long been a subject of dispute. Some commentators have seen it as a way of describing the planes and textures of the objects depicted; others as a means to an overall rhythmic animation of the picture surface itself, a way of being free in fact of any compulsion to describe. In Sisley's best works we see a synthesis of both. The rapid, exclamatory handling found so often in his treatment of water is both descriptive of the lapping, undulating surface of a flowing river and a way of transcribing its ceaseless reflections, broken and reformed by the current; the mobility of handling is the equivalent of the mobility of light as it captures and releases its fugitive impressions of trees, banks, boats, houses and sky. And it is this mobility – whether of grass and foliage, the passage of clouds, reflections on water, or sunlight on a building's façade–which constantly engaged Sisley's attention. Although he worked alongside Monet in the later sixties (they were at Honfleur in the summer of 1867, for example), it is not until 1870 that Sisley approaches Monet's free handling of similar themes–the water in the latter's *La Grenouillère* pictures of 1869 approximates Sisley's in the *Canal Saint-Martin*, though there is a softer, more delicate working here and more suggestion of depth.

Just as Sisley was beginning to participate confidently in the new movement, focusing his vision in line with his friends, the Franco-Prussian war dispersed the Impressionists. The convivial and argumentative evenings of discussion at the Café Guerbois, which Sisley sometimes attended, came to an end. Monet and Pissarro fled to London; Renoir was drafted into the army and nearly died of dysentery; Bazille, just beginning to find himself as a painter, joined up and was killed in November 1870. For Sisley personally the war was a disaster. His father was financially ruined and his health broken. When he died he left practically nothing, and the security to which Sisley and his family had become accustomed suddenly vanished. This turned Sisley from something of an independent amateur into a full-time painter who needed to sell to earn his living. From this time until his death in 1899 Sisley struggled incessantly against poverty, and though there were a few periods of relative calm, the search for patrons and sales hardly abated. Sisley was the only one of the original Impressionist group not to gain some measure of financial success during his lifetime. Even Pissarro, at the end of a life beleaguered by hardship, spent some years free of money troubles. However, when in very desperate circumstances, Sisley had

6

two or three friends on whom he could count. Chief among them was the dealer Paul Durand-Ruel, whom he met through Pissarro and Monet in 1871. Having dealt for some years in the work of Corot, Daubigny and the Barbizon school, Durand-Ruel identified himself with the young Impressionists (though Cézanne he refused to touch), bought their work, answered their appeals and gave them moral support. Although twice nearly ruined, he persevered, putting on exhibitions in Europe and later in New York, where he successfully opened a gallery. Among patrons Sisley might turn to were Eugène Murer, a pastry-cook and hotelier who amassed very cheaply (often as payment for meals) a large collection of Impressionist paintings, the baritone Jean-Baptiste Faure of the Opéra-Comique, and Georges Charpentier, publisher and particular patron of Renoir, whose wife's salon in the rue de Grenelle Sisley sometimes attended. Charpentier was frequently generous to Sisley, answering such appeals as this, written from Sèvres in 1879: 'Je suis dans le plus grand embarras et je pense que vous pourrez peut-être m'aider à en sortir. J'ai besoin d'une somme de quatre cents francs. J'ai six toiles, dont cinq nouvelles chez Legrand. Si vous pouvez disposer de cette somme, et vous m'obligeriez, elles sont à vous. Votre dévoué, A. Sisley.' Partly in order to economize (and the cost of living after the war rose steeply, particularly rents), Sisley and his family moved from Paris, first of all settling at Louveciennes (1871–5), then Marly-le-Roi (1875–7) and Sèvres (1877–80). All were within a short distance of Paris and yet were still sufficiently rural to provide innumerable subjects. In these places, in the surrounding fields and along the banks of the Seine, Sisley produced paintings which are among the most serene and confident landscapes of the century and which constitute his main contribution to Impressionism.

The word Impressionism can now be used more precisely. The war over, Sisley's friends also returned to the country around Paris or were frequent visitors – Renoir was in the capital, Pissarro in Louveciennes, were he saw much of Sisley, and Monet was at Argenteuil. They met regularly, worked together, and by 1874 had decided to form the 'Société Anonyme des Artistes Peintres, Sculpteurs, Graveurs', which held its famous first exhibition from 15 April to 15 May. Sisley participated in four of the eight Group exhibitions of the 'Impressionists', as they came to be called following a journalist's slur. By so doing, this retiring, conservative man identified himself with the most progressive movement of his day. But the scorn with which Monet, Cézanne and Pissarro were treated in the press was infrequently directed at Sisley. Certainly he was known as a prominent member of the group, but individual comments on his work tended to be peremptorily dismissive. Certainly he was depressed by the continually harsh reaction of the public; it was morally dispiriting and financially disastrous. But, like the others, nothing deflected him from an inner conviction that what he was doing was right and important and would eventually be accepted.

Sisley's life and work are inextricable from the Impressionist movement, with all its legends, heroism and mythology. Indeed one writer went so far as to say that he owes his 'current prestige not to his individuality but, precisely, to his participation in a movement'. It is only natural to ask what characteristics Sisley shares with the other Impressionists and what was his relation to the wider movement of nineteenth-century Realism. Must we alter our conception of Impressionism if we maintain, with several commentators, that Sisley was its most sedulous exponent? His temperament forbade any involvement with the kinds of subject that absorbed most of his fellow artists. We do not look to him for that contemporaneity of scene and detail, the spirit of 'la vie moderne' to be found in Manet or Renoir or Degas – unless we include his paintings of the Thames regattas of 1874. Nor do we find that transcription of intimate family life which engaged Monet or Berthe Morisot or Renoir (with the one exception of *The Lesson* [Plate 1],

sharing similarities with Monet's *The Sisley Family at Table* in the Bührle Collection). Unlike Pissarro, it seems he had little interest in the political movements of his day – his admiration for Courbet notwithstanding – and the sympathetic fellow-feeling which pervades some of Pissarro's scenes of rural life is absent in Sisley. Figures do appear in his work – hundreds of them – but they are devoid of significance as individuals and are included as animating dashes of colour, darker accents against light fields and grass, spatial punctuation often added at a late stage in the painting. There are fishermen, bargees, housewives, children bathing or at play, washerwomen, farm-workers, huntsmen, flirting couples, strollers on summer evenings, men unloading cargo, gossiping neighbours. Sisley sees them all as inevitable presences in the essentially domestic landscape he preferred. He is in close accord here with some of the Barbizon painters and with Constable and Crome.

Impressionism not only altered people's perception of their surroundings but insisted on a less exclusive, less censorious view of them. Sisley was in sympathy with this move towards a wider repertory of subjects, a move to include hitherto neglected or 'inartistic' aspects of modern life. If a factory chimney was an essential vertical in a composition, there was no question of missing it out; if the sunlight on an iron bridge crossed by a smoky train visually excited the painter, then he pitched his easel without qualm. Bazille had written in 1866 to his parents: 'I have chosen the modern era because it is the one I understand best, that I find most alive for living people – and that is what will get me rejected.' Sisley would have heard such sentiments and discussed them at the Café Guerbois and elsewhere. And though he never went as far as Monet in his explorations of the contemporary scene (he rarely painted in Paris after 1871), he was not averse to painting the *Bridge under Construction* (1885) or the prosaic *Sand Heaps* (Plate 33) by the Seine. In England, immediately after the first Impressionist exhibition, Sisley several times painted the new bridge at Hampton Court (Plates 22 and 23) with its massive pillars and metal railings, even to the point of painting from underneath it, its girders filling half the canvas (Plate 24). (It is interesting to note that in contemporary guides to Hampton, the bridge is described as 'ugly' and 'disfiguring'.) Undoubtedly such a novel viewpoint can be linked to photography; it indicates that emancipation from accepted, 'classic' landscape which was finally accomplished by Impressionism. But although Sisley was not afraid to strike a contemporary note where necessary, his subject-matter was invariably traditional. More than the other Impressionists, he was content to develop along earlier lines – there are, for instance, similarities of composition and mood with such landscape painters as François-Auguste Ravier and the gifted Antoine Chintreuil, a friend of Pissarro and admired by Redon. In some pictures there is a marked feeling for Japanese painting, particularly in the snow scenes such as *Snow at Louveciennes* (1874, Courtauld Institute, London) and in Sisley's combination in some works of widely differing perspectives. It is unlikely that he took much interest in recent scientific investigations into colour, and he remained unaffected by the Pointillism which Pissarro espoused and expounded. Anything Sisley owes to such investigations is more likely to originate from working alongside Monet and Renoir than from any theoretical application. Sisley embodies such characteristic features of Impressionism in moderation. Certainly he was stimulated to new ways of seeing and modes of expression by his early friendships with Bazille and Renoir and a little later by Monet and Pissarro. If he was not among the great innovators of the Impressionists such as Monet and Cézanne, he was distinctly of the movement and has his own particular interpretation. Without such pictures as *The Bridge at Hampton Court*, *Snow at Louveciennes*, *Flood at Port-Marly*, *The Footbridge at Argenteuil*, Impressionism would be impoverished.

Sisley's work has too often been judged as being entirely derivative. Venturi, for example, wrote that he 'invented nothing, but created works of art. Corot, Courbet, Pissarro and especially Monet taught him many things; he, Sisley, never taught anyone anything.' The French critic Jamot wrote that 'once provided with the technique transmitted by Monet, [Sisley] had no further ambition than to be the delightful minor poet of the country and seasons – nearer to Lépine (1835–92) and to Corot himself than to the author of *The Poplars* and *The Cathedrals*.' It is difficult to reconcile this view with such strong, individual paintings as mentioned above or some of the radiant late haystacks and views of Moret's church. Directness, simplicity, the judicious disposition of a few chosen elements characterize Sisley's best work. He avoids the plunging viewpoints of Monet's coastal paintings with their 'tumultuous pictorial fabric' no less than Pissarro's complex, architectural motifs. He is at his most convincing when a substantial, man-made structure contrasts with the surrounding fluidity of foliage, water and sky, and has an ability to situate and anchor such features with a succinct breadth of treatment, yet retain their weight and solidity. We see this most forcibly in the period 1870–80 in several paintings done at Marly-le-Roi – *The Waterworks* (Plate 13) and *The Aqueduct* (Plate 25), both reminders of the immensely daring waterfall constructed for Louis XIV behind his château, and views of the floods at nearby Port-Marly, with its sturdy inn stranded between water and sky (Plates 34 and 35). The dramatic human implications of such a scene (for we are looking in fact at a busy main street, full of shops and people – Sisley had painted it as such before the floods encroached from beyond the trees) are suppressed in favour of a detached lyricism where any drama is distilled in the door's black rectangle and its steady reflection. Sisley was incapable at any period of forcing his response and it is exactly this freedom from imposed feeling that gives such paintings their ability to move, surprise and enrich. All the small impressions, circuitous delights and particularities are subordinated to a total conception, as measured throughout as it is flexible in its details.

Sisley was finely endowed with constructive powers and one of his special achievements was the evocation of space. He is rarely complicated in this and depends on certain compositional features which vary little in his whole output. We have already noted, in connection with Corot's influence, his predilection for roads and pathways leading into the picture; avenues of poplars and plane trees similarly engaged him (Plates 10 and 44) and he was doubtless impressed, as François Daulte has suggested, by Hobbema's *The Avenue, Middelharnis*, which he would have seen in the National Gallery during his four years in London. Sometimes his roads and paths move gradually from one side of the canvas up to the other, sometimes they open fan-like, as in the snow scenes of Louveciennes; recession is suggested by the scale of figures and their atmospheric differentiation. He favours low horizons (there are no paintings entirely taken up by landscape); wide foregrounds of field, road or water, in which he often exaggerates the scale of stones, grass or ripples; a section of near detail from which the eye passes to distant vistas (Plate 17), tempering a too obvious recession; strong, interlocking horizontals crossed by verticals of trees, their reflections, fences and posts (as in several river views). But this spatial articulation cannot of course be divorced from Sisley's colour, and of all the Impressionists he had perhaps the most felicitous and perfectly pitched sense of tone, certainly during the period of about 1872–8. Though he never quite lost this sense, there are works of the 1880s where he throws a landscape into such a high colour key that the tonal adjustments falter.

In examining Sisley's colour we must keep in mind the admonishments against bright colour he would have heard at Gleyre's atelier and also his love for Corot. Renoir has recorded Gleyre's severe warnings against the use of clear, bright colour; like some distasteful vice, it was almost one's moral duty to avoid it – one might be blinded by it.

The reform of Sisley's palette was a gradual process and through the early seventies he often employed the light browns, ochres, pale blues and grey-greens which were his inheritance from Corot and from Courbet. His tonally subdued *View of Montmartre* (Plate 3) is the masterpiece of that early period (and should be compared to Corot's view of Ville d'Avray in the Louvre). The example of Renoir (whose work in the sixties, influenced by Diaz, astonished Sisley) and of Monet intervened, and he was launched into new discoveries of colour and handling. Shadows now revealed a multiplicity of colours, foliage was freed from the heavy chiaroscuro of Barbizon, walls of houses took on a range of lilacs, lemons, warm blues and dusty pinks; village streets became matted dashes and strokes of purple, peach yellow and blue grey (Plate 31).

Above all Sisley's precise sense of tone allowed him to use delicately graded blues in the suggestion of the air of a landscape and its recession towards the horizon. Corot's soft greys and silvered greens are replaced by a weft of luminous blues and lilac. But it is the sky which draws from Sisley some of his most personal colouring. In his letter to Tavernier, Sisley wrote of the immense importance to him of the sky and how he would begin a picture with it, establishing its various planes – 'for the sky, like the ground, has its planes' – and its tonal and rhythmic relations with the lie of the land or foliage in front of it. He exactly judges the effect on the sky of a brilliant cornfield touching it and the tense dialogue of colour between the two (Plate 14); he gauges with perfect control the relation between snow-bound earth and a sky heavy with snow to come – through analogous tones as much as through the density of the paint textures. Dramatic and stormy skies are not common in his work. We find no equivalent of Daubigny's turbulent sunsets with their molten vermilions and oranges. He seems less eager to explore the extreme evanescence of sunrise and sunset, or the crepuscular effects of Whistler, or Boudin's moonlit views. Unlike Monet or Pissarro, it seems Sisley never attempted painting at night. Nevertheless his variety is impressive – from absolutely limpid summer blues gaining in density towards the zenith, to skies of great animation where swiftly moving clouds are streaked and bruised with ochre, indian red and empurpled grey. There are skies which recall Van Gogh and Vlaminck in their vehemence, where thick, square-ended brushstrokes move rapidly across areas of uniform colour; others in which Sisley uses malachite, lemon and rose to evoke the most discriminative nuances of atmospheric change. He can give us skies we have never seen before, just as Pissarro shows us earth of a palpable fertility or Monet both, in a world of water.

What is seen rather than known, what is revealed to the eye and what suppressed by light, whether from a frank and constant source or veiled, interrupted, passing – this was Sisley's continual preoccupation. And this fundamental characteristic of Impressionism – the High Impressionism of the seventies – he held to; when we speak of the crisis of Impressionism which in the eighties considerably altered the work of Renoir or Pissarro, we may exclude Sisley. But even during those years there are changes in his work which suggest restlessness and dissatisfaction, a willingness to sacrifice some of his most personal features to follow Renoir or Monet, and a distinct faltering of his perceptions. His essentially lyrical response flickers intermittently over the chosen subject. In the late eighties especially, we see him trying to animate lifeless foliage and exhausted fields; even Moret in broad sunlight becomes an echo of former energies. It is in Sisley's handling of paint that these changes become most apparent. Surface was always crucial to him and he wrote of it:

> To give life to the work of art is certainly one of the most necessary tasks of the true artist. Everything must serve this end: form, colour, surface. The artist's impression is the life-giving factor, and only this impression can free that of the spectator.

And though the artist must remain the master of his craft, the surface, at times raised to the highest pitch of liveliness, should transmit to the beholder the sensation which possessed the artist.

You see that I am in favour of a variation of surface within the same picture. This does not correspond to customary opinion, but I believe it to be correct, particularly when it is a question of rendering light-effects. Because when the sun lets certain parts of a landscape appear soft, it lifts others into sharp relief. These effects of light, which have an almost material expression in nature, must be rendered in material fashion on the canvas.

(Letter to A. Tavernier, from *Artists on Art*, eds. Goldwater & Treves, New York, 1945).

If we look at the trees in the *Bridge at Hampton Court* (Plate 23), they are brushed in with consummate ease, shaped by generous strokes of colour, calligraphic in their relaxed rhythms; the sky is rendered even more broadly, the brushstrokes plainly visible; the river is densely textured with full, generally parallel dabs of pigment over which Sisley places longer, thinner strokes of dry pale blue. There is variety here, but it is the result of immediate necessity and only partially directed by surface considerations. If we examine a later painting, the facture is more complex. Paint is less succulently applied, strong accents dissolve in a matted impasto; commas, dashes, spots and loops, put on with small brushes, make up a rough, agitated surface. Trees become furry and congealed, their rhythmic coherence lost in febrile scumbling. By such methods Sisley frequently creates an impression of false excitement, losing those qualities of pristine statement and unforced handling remarkable in his earlier works.

There were, however, periods of recovery, especially in the mid-eighties and the early nineties. Such a painting as the 1884 *Canal du Loing* (in the Louvre) is representative of a group of pictures from that year and the following one, in which Sisley's colour owes something to Renoir's chromatic brilliance. Sharper colour-schemes predominate – apple greens, lemons, the vermilion of roof-tops, adventurous violets and pinks, touches of Prussian blue. Some of these landscapes have the freshness of Van Gogh's first Provençal orchards (how close the compositions are of these very dissimilar painters). To the early nineties belong further paintings to prove that Sisley, once his early lyricism had withered, was capable of renewal – among them many views of Moret seen across the river, of haystacks and of the church at Moret. Some of the paintings of the old town viewed from across the Loing are of a dream-like clarity, images of longing for landscapes of the imagination. Haystacks burn with chrome and purple, fertile structures in sunlit fields (Plates 42 and 43). Thinly painted, delicate scenes along the river, often misty or in evening sunlight, evoke the mood of Delius's elegiac music, composed at Grez, a few miles downstream from Moret. Of the Eglise Notre-Dame there are over a dozen paintings, done in 1893–4 at various times of the day, in different weathers, and in different seasons (Plates 46 and 47). The church, consecrated by Thomas à Becket but mainly built in the thirteenth and fourteenth centuries, was close to Sisley's house in Moret; it is seen from the south-west, a covered market along its south side, the street disappearing sharply past the west front. Undoubtedly Monet's *Rouen Cathedral* series (1891–3) inspired Sisley, though it is doubtful if he had seen them; they were not exhibited until 1895 and Monet was well known for his secrecy and dislike of showing new work even to close friends. On the other hand Sisley may have inspired Pissarro's several paintings of Saint-Jacques, Dieppe (1901), closer to Sisley in their small-town *mise-en-scène* than to Monet's more conceptual variations. In all these works of the early nineties, often too summarily dismissed, the combination of natural and solid, man-made elements draws from Sisley works that are tautly conceived, restrained in their handling, and showing once more what Roger Fry described as Sisley's 'infallible

instinct for spacing and proportion'. Writing some years earlier to his son Lucien (May 1887), Pissarro lamented Sisley's failure at that time: '. . . he is adroit, delicate enough, but absolutely false . . .'; and a day later: 'As for Sisley, I just can't enjoy his work, it is commonplace, forced, disordered; Sisley has a good eye, and his work will certainly charm all those whose artistic sense is not very refined.' Such judgements are appropriate to much of the work of the late eighties; but Pissarro later wrote (22 January 1899, a week before Sisley's death): 'He is a great and beautiful artist, in my opinion he is a master equal to the greatest. I have seen works of his of rare amplitude and beauty, among others an *Inundation*, which is a masterpiece.'

It is invariably suggested that Sisley became reclusive and misanthropic towards the end of his life, partly through the gnawing lack of recognition of his work. There is little evidence for this – rather, that in spite of his hardships, he remained cheerful and could be stimulating company, as the critic Gustave Geffroy discovered on a visit to Moret. After several years in the vicinity of Moret, the Sisleys moved into the town in November 1889. Sisley's final home was a modest house with a garden in the rue du Château, close to the church. Geffroy describes the splendid welcome and luncheon he was given, and the rooms of the house piled with canvases. He was struck by Sisley's resigned dignity, good manners and cultivated conversation. Another commentator mentions as Sisley's English inheritance 'une certaine correction de tenue et des faux-cols irréprochablement blancs' (J. Leclerq, 'Sisley', *Gazette des Beaux-Arts*, March 1899). We learn that he was well read and adored music: '. . . he went assiduously to the Pas de Loup concerts and . . . music was an obsession with him: he sang unceasingly, hummed "that gay, melodious and enthralling phrase that became a part of me" from the scherzo of a Beethoven Quartet.' (R. Huyghe, *Formes*, November 1931).

Sisley continued to see friends, though less regularly than before, and there were several visits to the Monet-Hoschedé household at Giverny. Sisley was present on the famous occasion of Cézanne's stay there when he suddenly left the dining table and bolted back to Aix. Jeanne and Pierre Sisley were friends of Monet's two sons and his Hoschedé stepchildren; at one point Germaine Hoschedé and Pierre wished to marry but he was thought unsuitable, having taken up the vague and unprofitable career of inventor. He and Jeanne (a beauty who married and died young) attended a wedding at Giverny in 1900 and were included in the inevitable family photograph. Pierre died destitute in Paris in 1929, though with several of his father's pictures still in his possession.

Sisley left France three times after his initial stay in London as a young man. He spent four months in England in 1874 on a visit financed by Jean-Baptiste Faure and produced the celebrated series of paintings at Hampton Court – boating, regattas, Garrick's villa and Molesey Weir – as well as one painting of the Thames at Westminster. In June 1881 he went to the Isle of Wight but it was an abortive visit, his canvases failing to arrive from Paris; he was possibly too financially restricted to buy some locally. His last absence from France was on a painting holiday in South Wales in 1897. He first visited London and then Falmouth before settling at Penarth, just south of Cardiff and overlooking the Bristol Channel. It was the first occasion on which he had painted the sea – often seen from the cliff-tops, intrepid bathers below on the shingled beach of Langland Bay, enormous rocks perched at the water's edge: all subtle meditations on the changing surface and colour of the sea stretching to imperceptible horizons. One can only regret that Sisley took up this subject so late in his life. There is also from this stay a sketch-book of vivid drawings, a letter to Geffroy describing his contentment with his lodgings and the superb coastline, and a drawing of the lounge of the Osborne Hotel.

In October Sisley returned to Moret and in the following year it was discovered that he was suffering from cancer of the throat. On 8 October 1898 Mme Sisley died of cancer of the tongue. 'Sisley was the soul of devotion,' Renoir recounted, 'looking after her tirelessly, watching over her as she lay in her chair trying to rest.' Sisley's health rapidly dwindled until he was hardly able to turn his head and certainly unable to paint. In the New Year he sent for Monet to ask him to take care of his children, and a week later, on 29 January 1899, he died. He was buried in Moret cemetery in the presence of Monet, Renoir, Adolphe Tavernier and the painter Cazin. In 1911 a bust was erected in Moret to his memory.

Select Bibliography

Leclerq, J., 'Alfred Sisley', *Gazette des Beaux-Arts*, March 1899.

Geffroy, G., *Sisley*, Paris, 1923.

Fry, R., 'Sisley', *Nation and Athenaeum*, 3 December 1927.

Huyghe, R., 'Some unpublished letters of Sisley', *Formes*, November 1931.

Besson, G., *Sisley*, Paris, n.d.

Sisley, C., 'The Ancestry of Alfred Sisley', *Burlington Magazine*, September 1949.

Alfred Sisley (exhibition catalogue), Berner Kunstmuseum, Berne, 1958.

Robida, M., *Le Salon Charpentier et les Impressionnistes*, Paris, 1958.

Daulte, F., *Alfred Sisley, catalogue raisonné de l'œuvre peint*, Lausanne, 1959.

Rewald, J., *The History of Impressionism*, New York, 1961; new edition 1973.

Renoir, J., *Renoir, my Father*, London, 1962.

Scharf, A., *Sisley*, no. 24 of *The Masters*, London, 1966.

Ashbery, J., 'The Unknown Sisley', *Art News*, vol. 65, 1966.

Lanes, J., Review of Wildenstein's *Sisley* exhibition (New York), *Burlington Magazine*, December 1966.

Poole, P., *Impressionism*, London, 1967.

Daulte, F., *Alfred Sisley*, Milan, 1972.

Alfred Sisley, Landscapes (exhibition catalogue), Nottingham University Art Gallery, 1971.

The Impressionists in London (exhibition catalogue), Hayward Gallery, London, 1973

Forge, A., *et al.*, *Monet at Giverny*, London, 1975.

Outline Biography

1839	Born on 30 October in Paris, of English parents.
1857–61	In London, preparing for a career in commerce.
1862–3	Studies at the atelier Gleyre, Paris, where he meets Bazille, Renoir and Monet.
1863–70	Works frequently in the Forest of Fontainebleau.
1866	Exhibits two pictures at the Salon. Marries Marie Lescouezec; two children, Pierre and Jeanne.
1870–1	During the Franco-Prussian war Sisley *père* loses the family business and dies, thus leaving Sisley and his family with no independent income.
1874	Exhibits in the first Impressionist exhibition, 35 Boulevard des Capucines, Paris. Paints in England from July to October, mainly at Hampton Court.
1874–7	Lives at Marly-le-Roi.
1876	Paints the floods at Port-Marly. Exhibits at the second Impressionist exhibition.
1877	Exhibits at the third Impressionist exhibition.
1877–80	Lives at Sèvres.
1880	Moves to Veneux-Nadon, near Moret-sur-Loing.
1881	One-man exhibition at the offices of *La Vie Moderne*, Paris. Visits the Isle of Wight.
1882	Exhibits twenty-seven paintings at the seventh Impressionist exhibition.
1883	One-man exhibition at the Galerie Durand-Ruel.
1887	Exhibits in May at the Second International Exhibition, Paris.
1889	Moves with his family to a house in Moret-sur-Loing.
1890	Exhibits with the Société Nationale, Paris, and annually (except 1896 and 1897) until his death.
1894	Paints a series of pictures of the Eglise Notre-Dame, Moret. Visits Normandy in the summer and paints there.
1897	Large retrospective exhibition at the Galerie Georges Petit attracts little attention. Summer spent in England and South Wales.
1898	Mme Sisley dies.
1899	Dies on 29 January at Moret-sur-Loing.

List of Plates

1. *The Lesson: Pierre and Jeanne Sisley.* 1871. Canvas, 40 × 47 cm. Private Collection.
2. *Still-Life with Heron.* 1867. Canvas, 81 × 100 cm. Paris, Louvre (Jeu de Paume).
3. *View of Montmartre from the Cité des Fleurs.* 1869. Canvas, 70 × 116.8 cm. Grenoble, Musée de Peinture.
4. *The Canal Saint-Martin.* 1869. Canvas, 38 × 46.5 cm. Paris, Louvre (Jeu de Paume).
5. *Barges on the Canal Saint-Martin.* 1870. Canvas, 54.6 × 73.7 cm. Winterthur, Oskar Reinhart Collection.
6. *The Ile Saint-Denis.* 1872. Canvas, 50.5 × 65 cm. Paris, Louvre (Jeu de Paume).
7. *Early Snow at Louveciennes.* About 1870. Canvas, 54.6 × 73 cm. Boston, Museum of Fine Arts (J. T. Spaulding Bequest).
8. *Footbridge at Argenteuil.* 1872. Canvas, 39 × 60 cm. Paris, Louvre (Jeu de Paume).
9. *Bridge at Villeneuve-la-Garenne.* 1872. Canvas, 49.5 × 65.4 cm. New York, Metropolitan Museum of Art (Gift of Mr and Mrs Henry Ittleson, Jr).
10. *The Chemin de Sèvres, Louveciennes.* 1873. Canvas, 54.7 × 73 cm. Paris, Louvre (Jeu de Paume).
11. *Square at Argenteuil.* 1872. Canvas, 46.5 × 66 cm. Paris, Louvre (Jeu de Paume).
12. *Boats at the Lock, Bougival.* 1873. Canvas, 46 × 65 cm. Paris, Louvre (Jeu de Paume).
13. *The Waterworks of Louis XIV at Marly.* 1873. Canvas, 45 × 64.5 cm. Copenhagen, Ny Carlsberg Glyptotek.
14. *Wheatfields near Argenteuil.* 1873. Canvas, 50.2 × 73 cm. Hamburg, Kunsthalle.
15. *The Garden.* 1873. Canvas, 46 × 65 cm. St Gallen, Kunstmuseum.
16. *Misty Morning.* 1874. Canvas, 50.5 × 65 cm. Paris, Louvre (Jeu de Paume).
17. *Louveciennes, Hauteurs de Marly.* About 1873. Canvas, 38 × 46.5 cm. Paris, Louvre (Jeu de Paume).
18. *The Furrows.* 1873. Canvas, 45.5 × 64.5 cm. Copenhagen, Ny Carlsberg Glyptotek.
19. *Regatta at Molesey.* 1874. Canvas, 66 × 91.5 cm. Paris, Louvre (Jeu de Paume).
20. *The Village of Voisins.* 1874. Canvas, 38 × 46.5 cm. Paris, Louvre (Jeu de Paume).
21. *Church Tower at Noisy-le-Roi.* 1874. Canvas, 45 × 60 cm. Glasgow, Art Gallery (Burrell Collection Loan).
22. *Bridge at Hampton Court.* 1874. Canvas, 51 × 69 cm. Private Collection.
23. *Bridge at Hampton Court.* 1874. Canvas, 45.7 × 61 cm. Cologne, Wallraf-Richartz Museum.
24. *Under the Bridge at Hampton Court.* 1874. Canvas, 50 × 76 cm. Winterthur, Kunstmuseum.
25. *The Aqueduct at Marly.* 1874. Canvas, 54.3 × 81.3 cm. Toledo, Ohio, Museum of Art (Gift of Edward Drummond Libbey).
26. *Snow at Louveciennes.* 1878. Canvas, 61 × 50.5 cm. Paris, Louvre (Jeu de Paume).
27. *Snow at Louveciennes.* 1874. Canvas, 56 × 45.7 cm. Washington, D.C., Phillips Collection.
28. *Watering-Place at Port-Marly.* 1875. Canvas, 39.4 × 56.5 cm. Chicago, Art Institute (Mrs Clive Runnells Collection).
29. *Watering-Place at Port-Marly.* 1875. Canvas, 38.5 × 61.5 cm. Zurich, Bührle Collection.
30. *Near Marly: Snow on the Road to Saint-Germain.* 1874–5. Canvas, 44 × 54 cm. Zurich, Bührle Collection.
31. *A Street in Marly.* 1876. Canvas, 50 × 64.8 cm. Mannheim, Kunsthalle.
32. *Men Sawing.* 1876. Canvas, 50 × 65 cm. Paris, Musée du Petit Palais.
33. *Sand Heaps.* 1875. Canvas, 54 × 65.7 cm. Chicago, Art Institute (Mr and Mrs Martin A. Ryerson Collection).
34. *Flood at Port-Marly.* 1876. Canvas, 60 × 81 cm. Paris, Louvre (Jeu de Paume).
35. *The Boat in the Flood.* 1876. Canvas, 50.5 × 61 cm. Paris, Louvre (Jeu de Paume).
36. *Summer at Bougival.* 1876. Canvas, 46 × 62 cm. Zurich, Bührle Collection.
37. *Woman Resting by a Stream at the Edge of a Wood.* 1878. Canvas, 73.5 × 80.5 cm. Paris, Louvre (Jeu de Paume).
38. *'Sous la Neige'.* 1876. Canvas, 38 × 55 cm. Paris, Louvre (Jeu de Paume).
39. *Snow at Veneux-Nadon.* About 1879. Canvas, 55 × 74 cm. Paris, Louvre (Jeu de Paume).
40. *Avenue of Poplars near Moret.* 1890. Canvas, 62.5 × 81 cm. Nice, Musée des Beaux-Arts Jules Chéret.
41. *Small Meadows in Spring.* About 1882–5. Canvas, 54 × 73 cm. London, Tate Gallery.

42. *Haystack at Moret, October.* 1891. Canvas, 64.8 × 91.4 cm. Douai, Musée Municipal.

43. *Haystacks at Moret, Morning Light.* 1891. Canvas, 73.8 × 93.1 cm. Melbourne, National Gallery of Victoria (Felton Bequest).

44. *The Canal du Loing at Moret.* 1892. Canvas, 73 × 93 cm. Paris, Louvre (Jeu de Paume).

45. *Bridge at Moret.* 1893. Canvas, 73.5 × 92.3 cm. Paris, Louvre (Jeu de Paume).

46. *The Church of Notre-Dame at Moret in Sunshine.* 1893. Canvas, 64.8 × 81.3 cm. Rouen, Musée des Beaux-Arts.

47. *The Church of Notre-Dame at Moret after Rain.* 1894. Canvas, 73 × 60 cm. Detroit, Institute of Arts.

48. Detail of Plate 41.

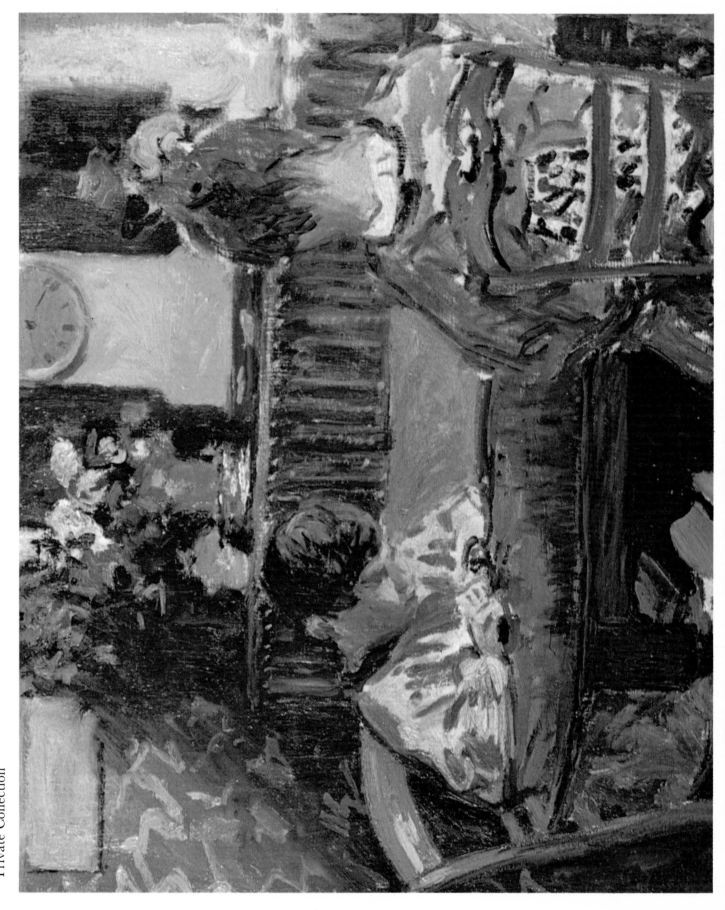

1. *The Lesson: Pierre and Jeanne Sisley.* 1871.
Private Collection

2. *Still-Life with Heron.* 1867.
Paris, Louvre (Jeu de Paume)

3. *View of Montmartre from the Cité des Fleurs.* 1869.
Grenoble, Musée de Peinture

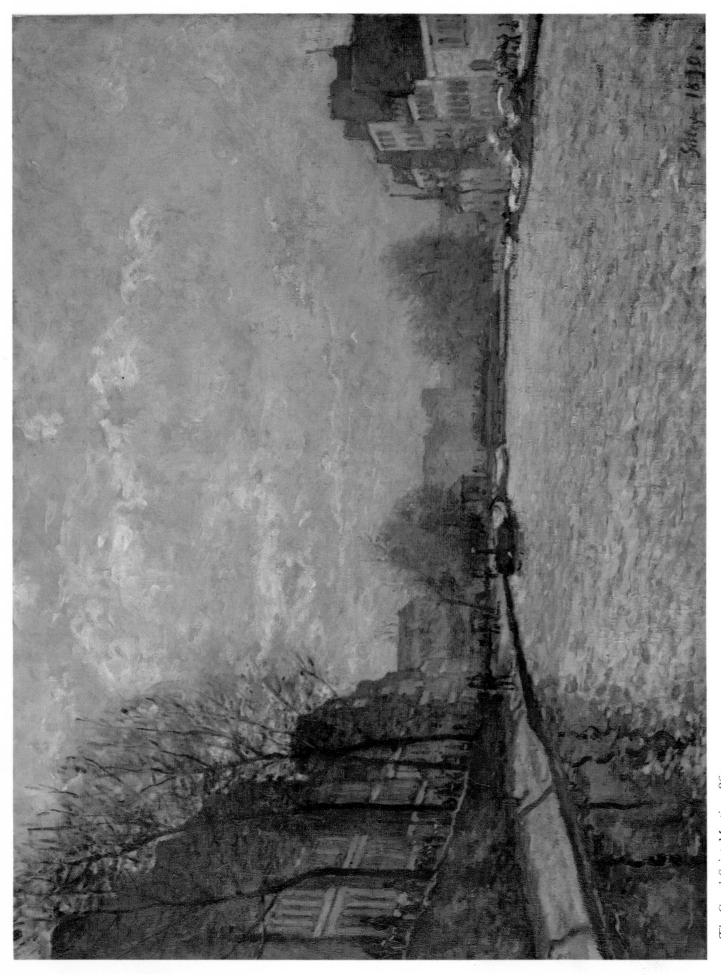

4. *The Canal Saint-Martin*. 1869.
 Paris, Louvre (Jeu de Paume)

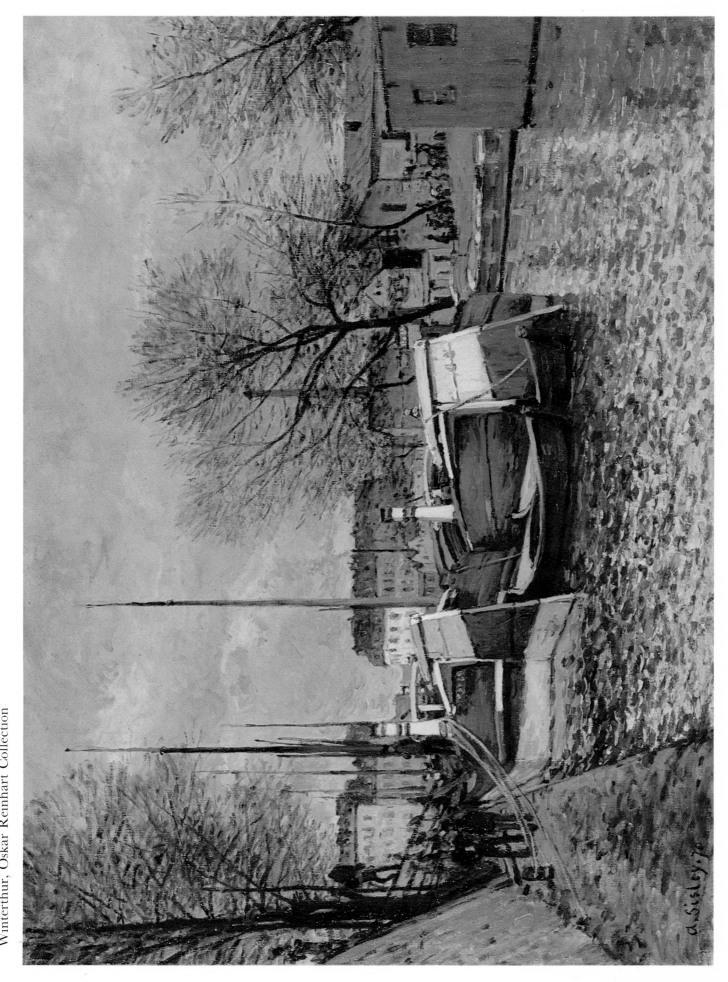

5. *Barges on the Canal Saint-Martin.* 1870.
Winterthur, Oskar Reinhart Collection

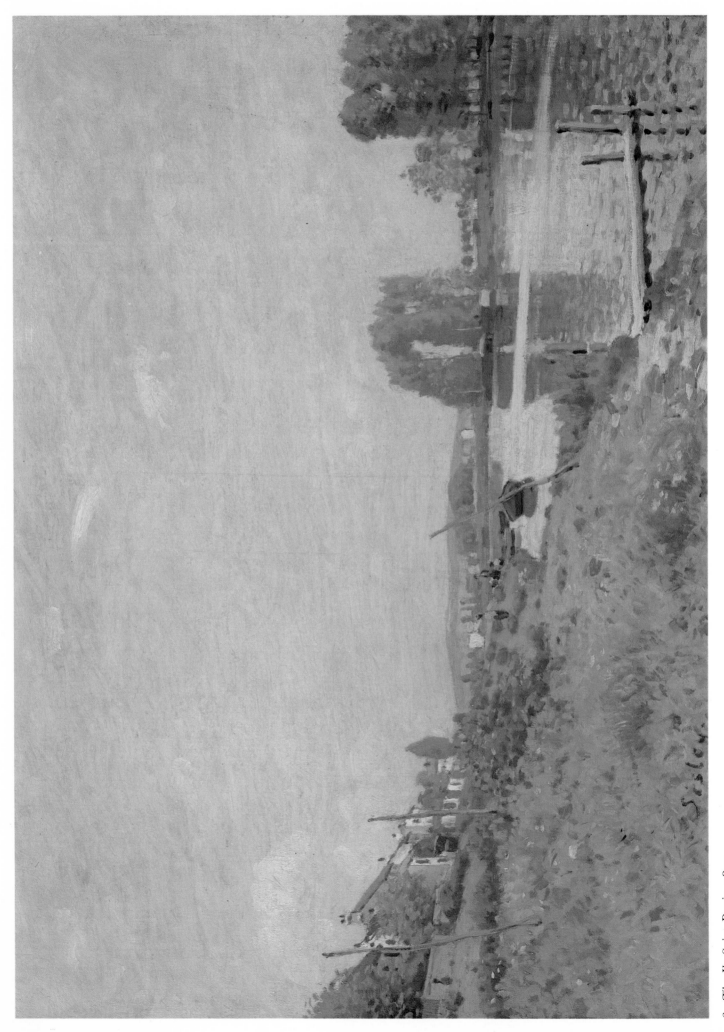

6. *The Ile Saint-Denis*, 1872.

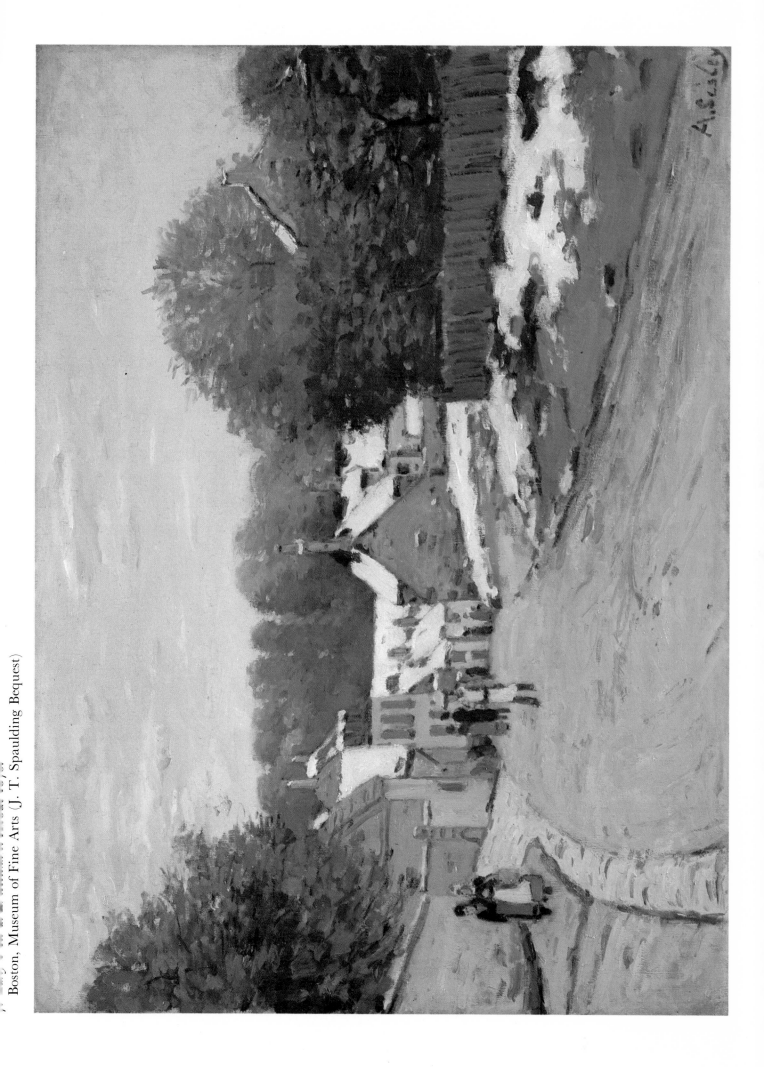

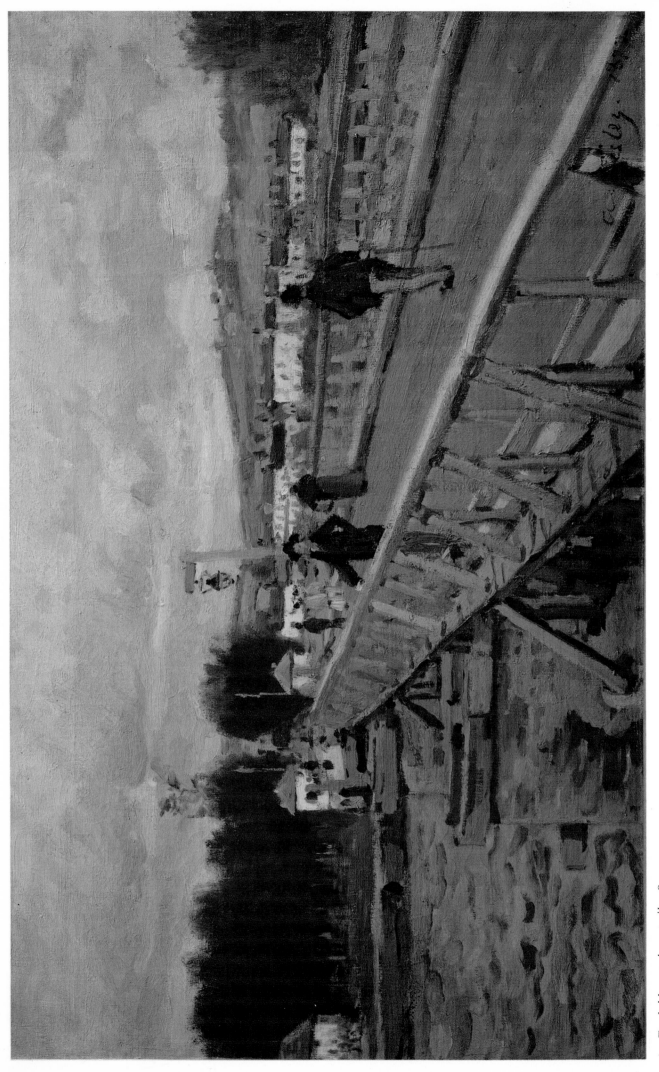

8. *Footbridge at Argenteuil.* 1872.
Paris, Louvre (Jeu de Paume)

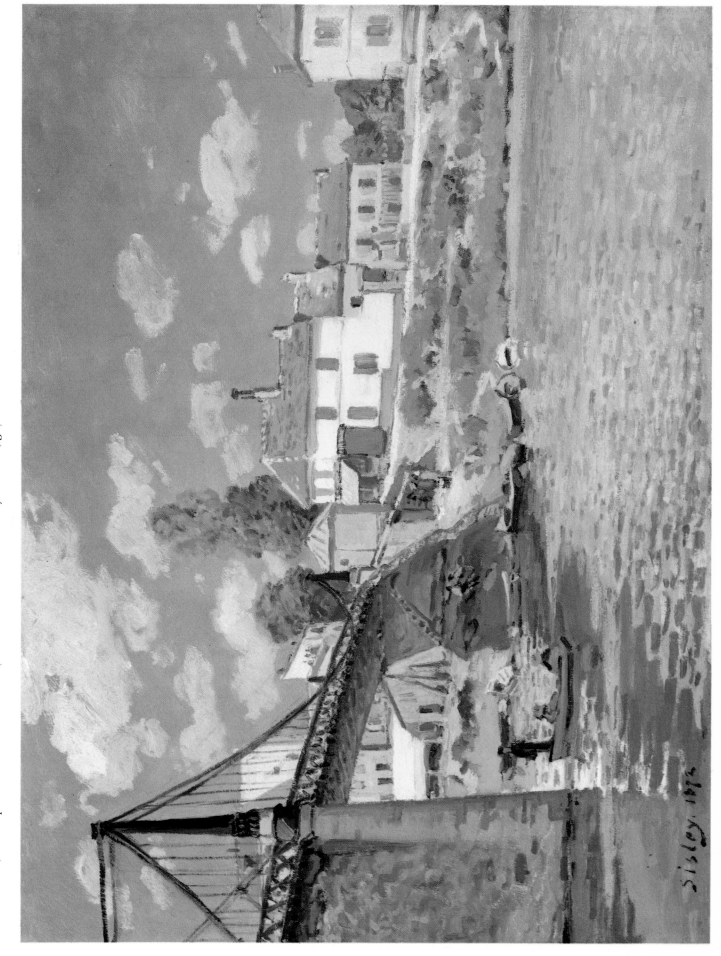

9. *Bridge at Villeneuve-la-Garenne.* 1872.
New York, Metropolitan Museum of Art (Gift of Mr and Mrs Henry Ittleson, Jr)

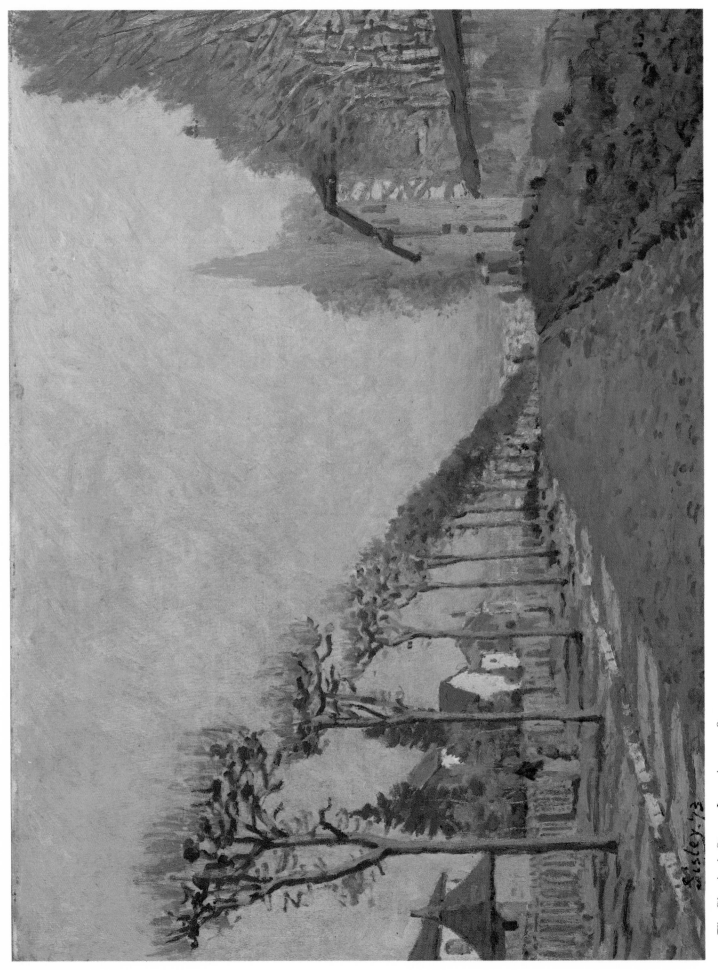

10. *The Chemin de Sèvres, Louveciennes.* 1873.
Paris, Louvre (Jeu de Paume)

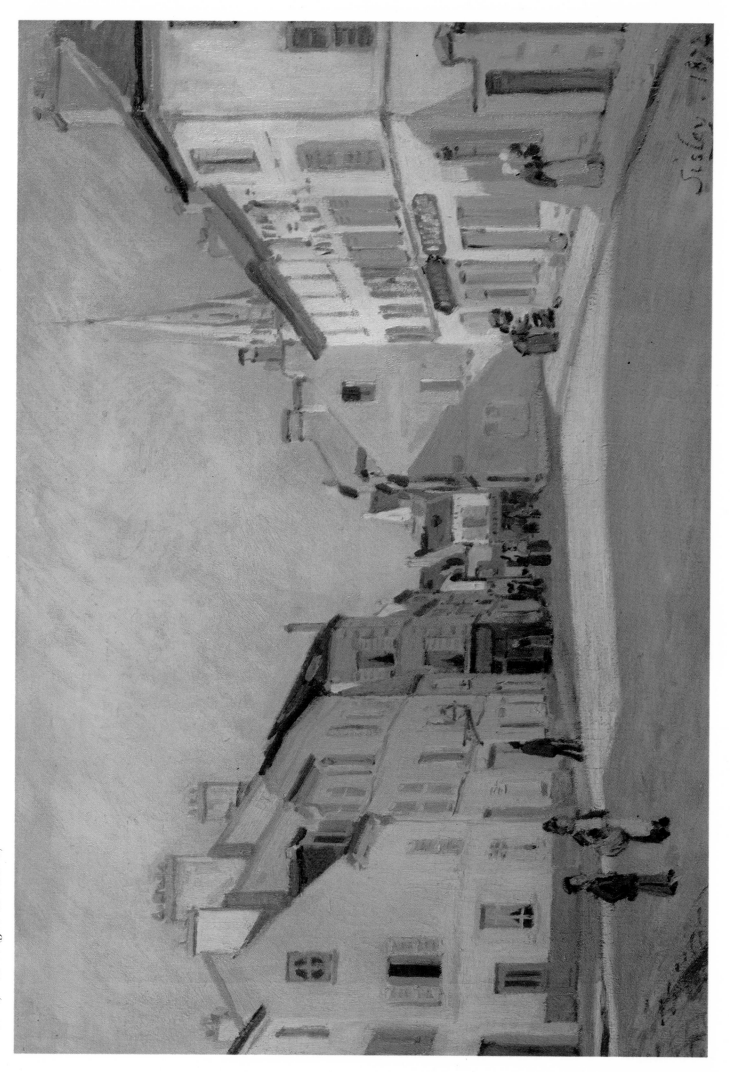

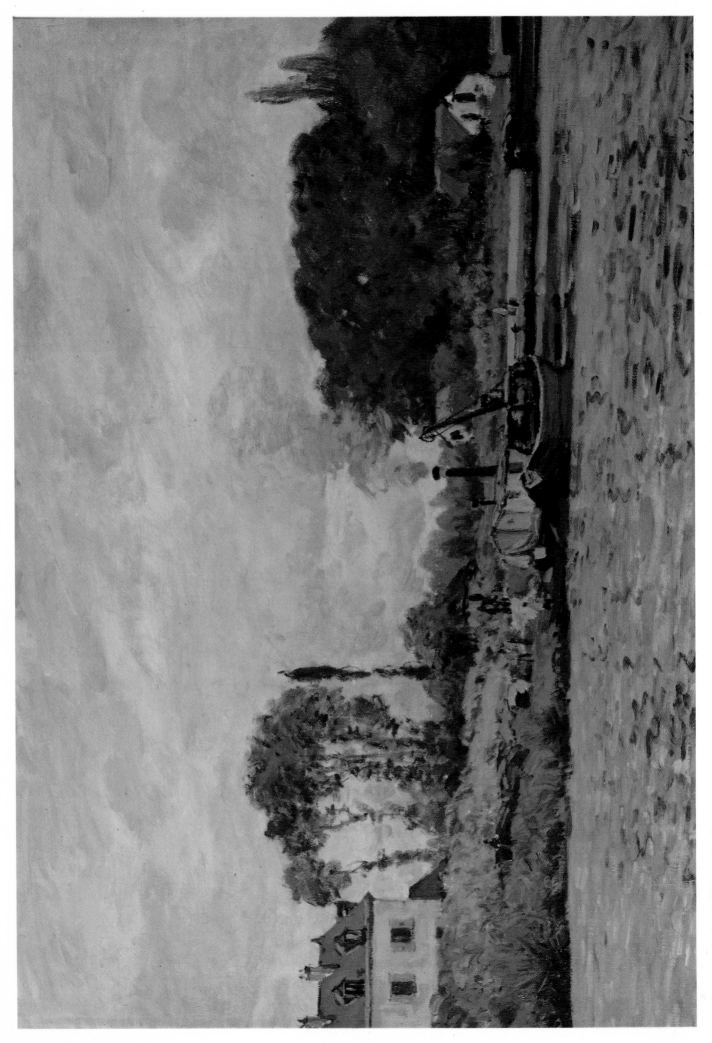

12. *Boats at the Lock, Bougival.* 1873.
Paris, Louvre (Jeu de Paume)

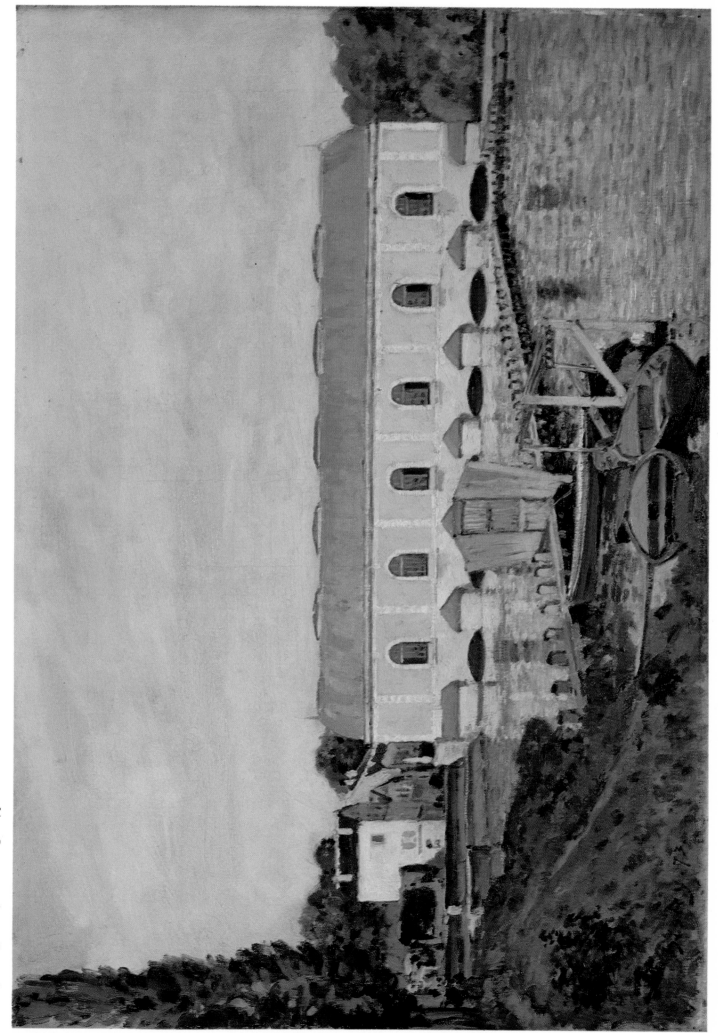

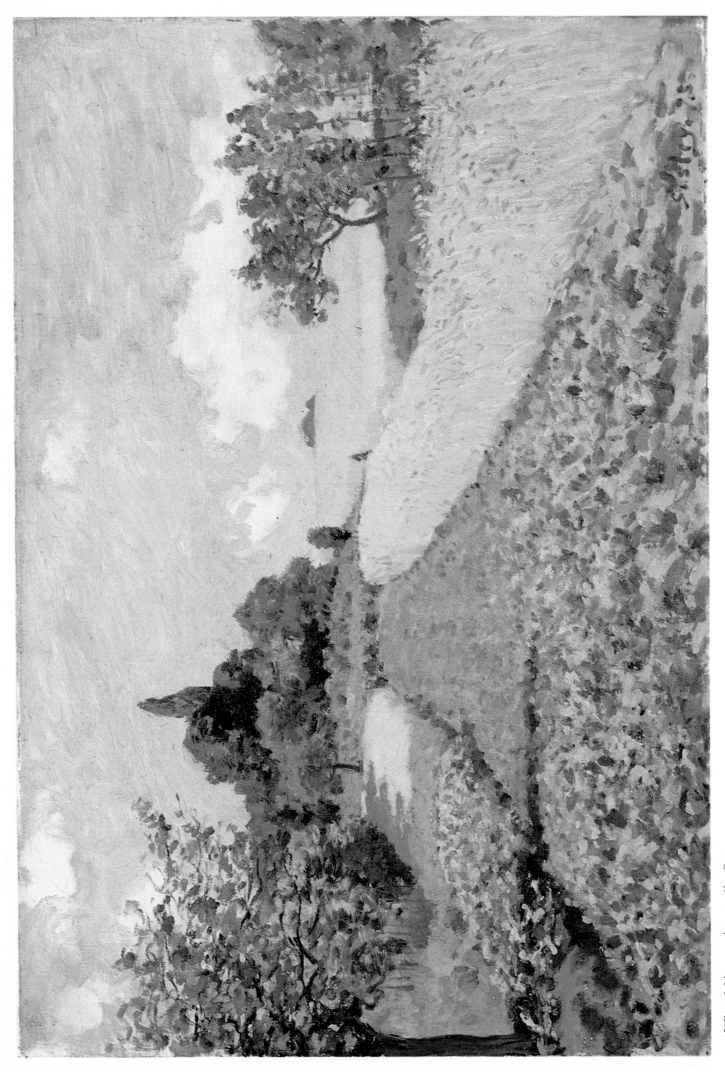

14. *Wheatfields near Argenteuil.* 1873.

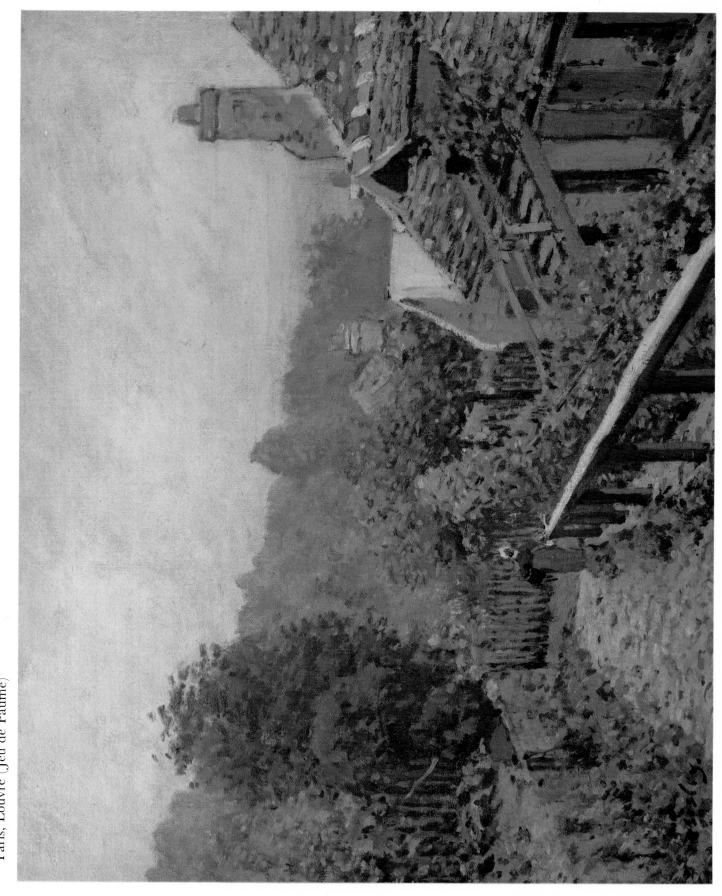

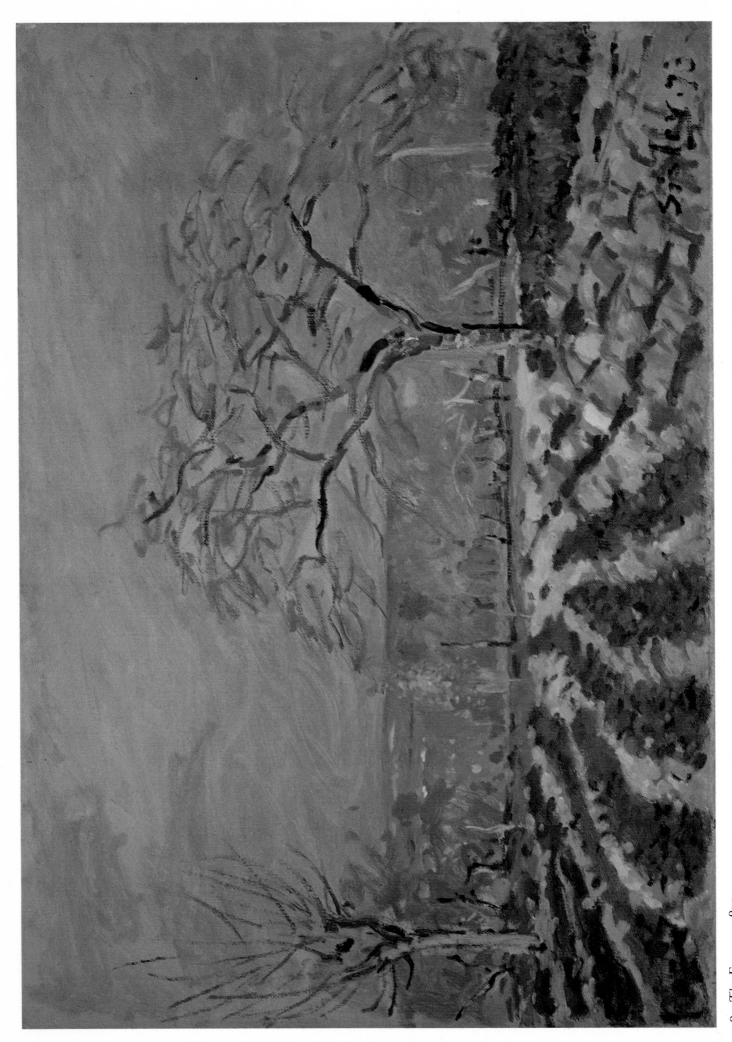

18. *The Furrows.* 1873.

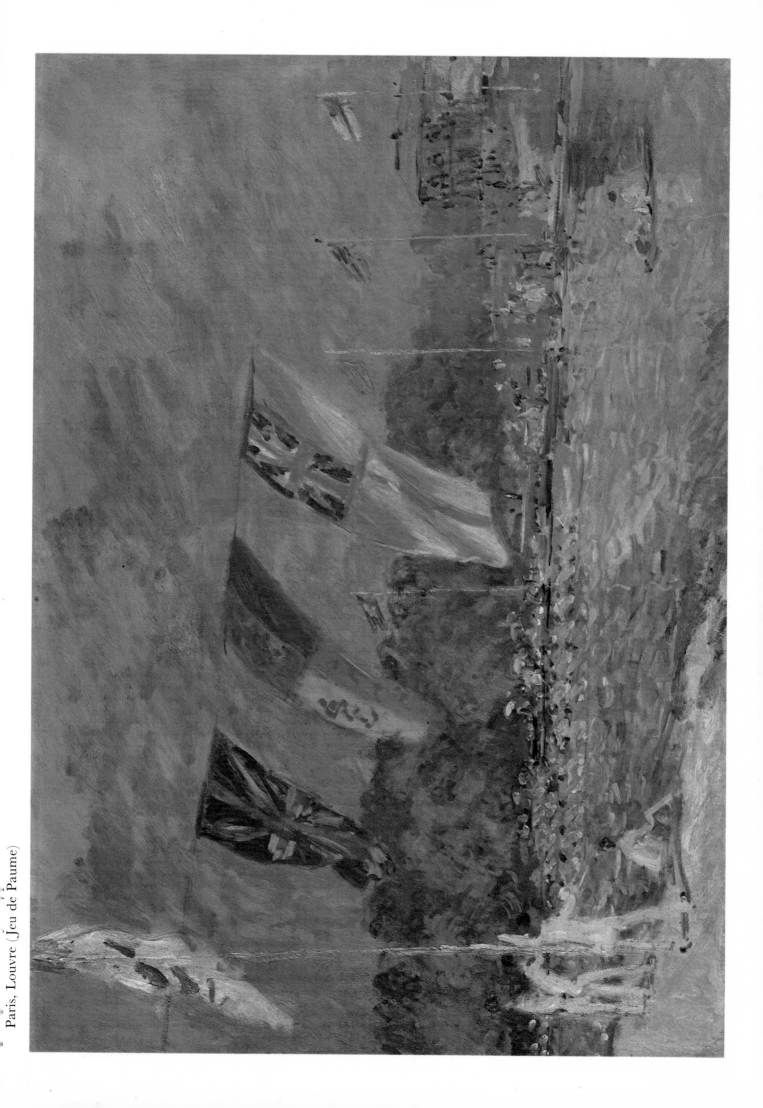

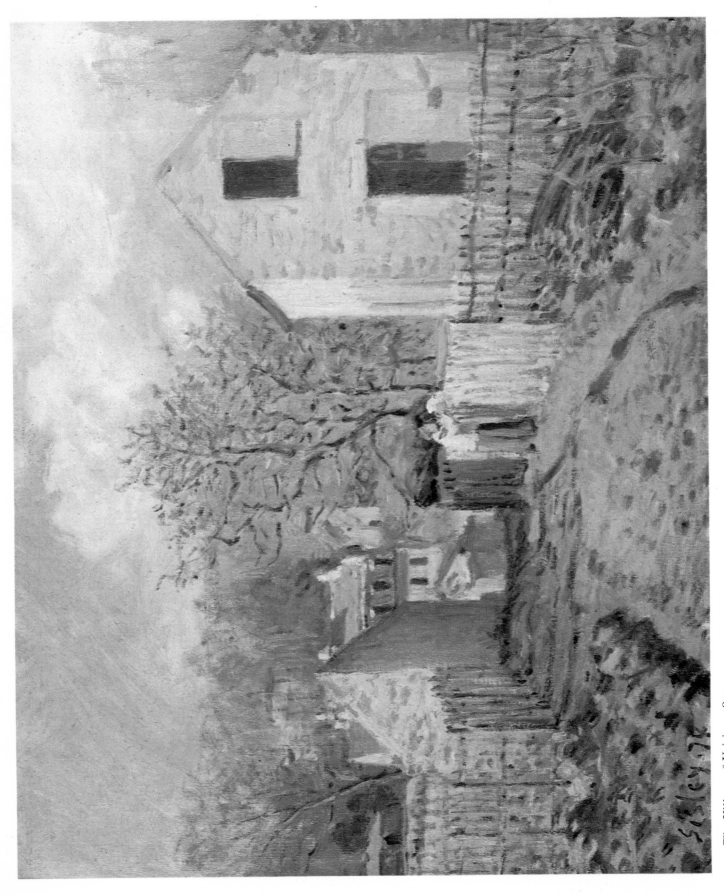

20. *The Village of Voisins.* 1874.

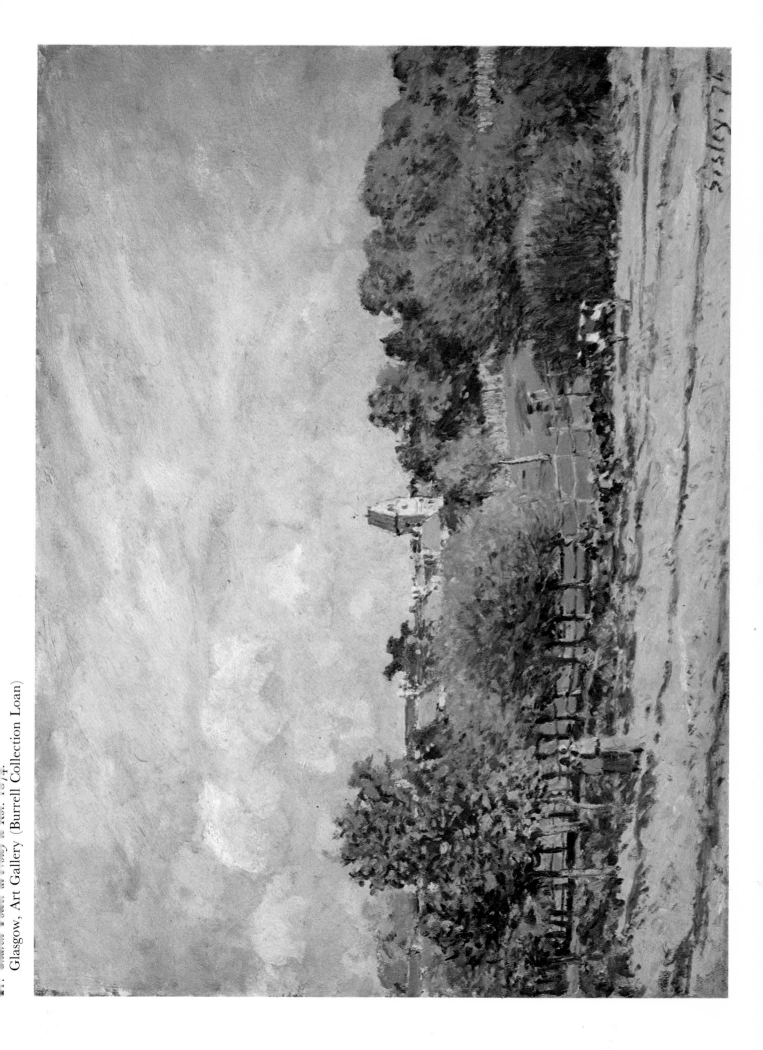

Glasgow, Art Gallery (Burrell Collection Loan)

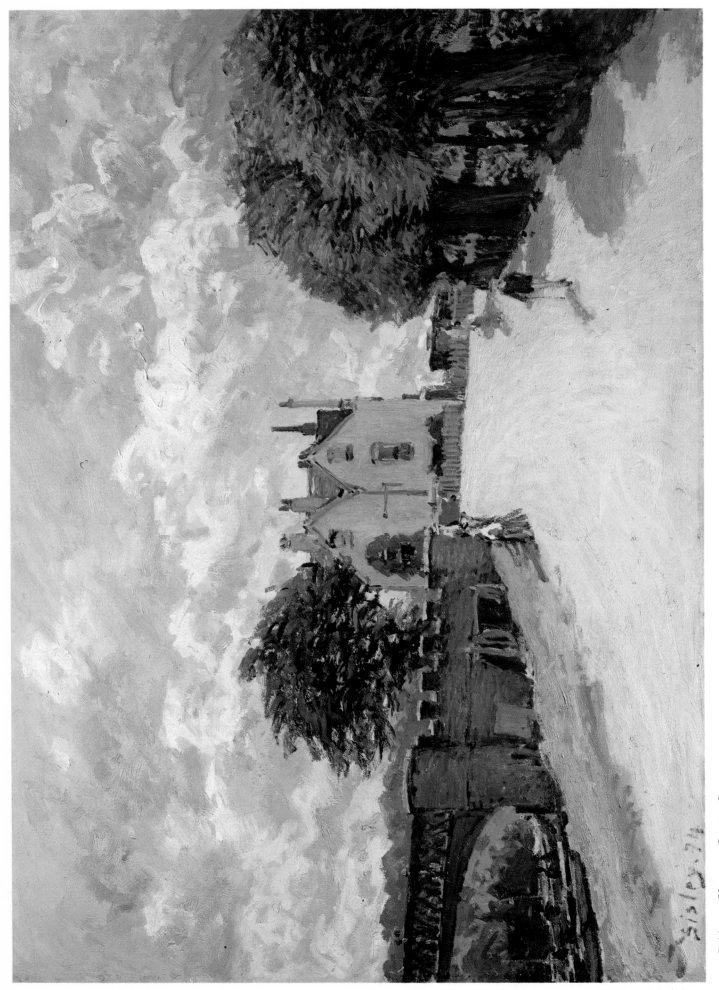

22. *Bridge at Hampton Court.* 1874.
Private Collection

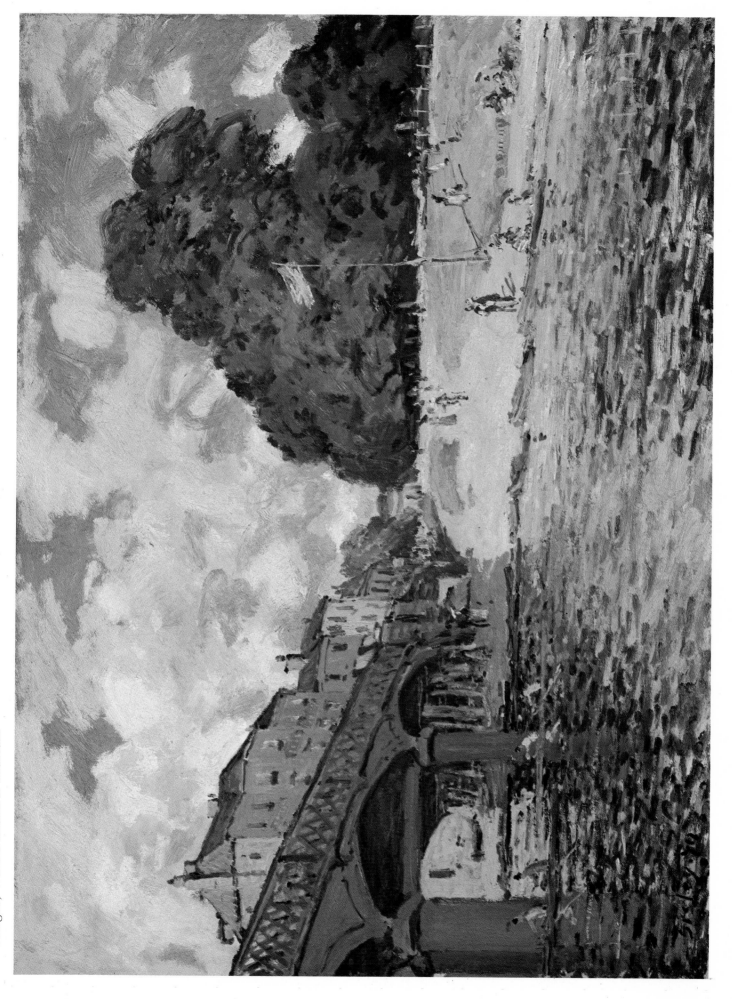

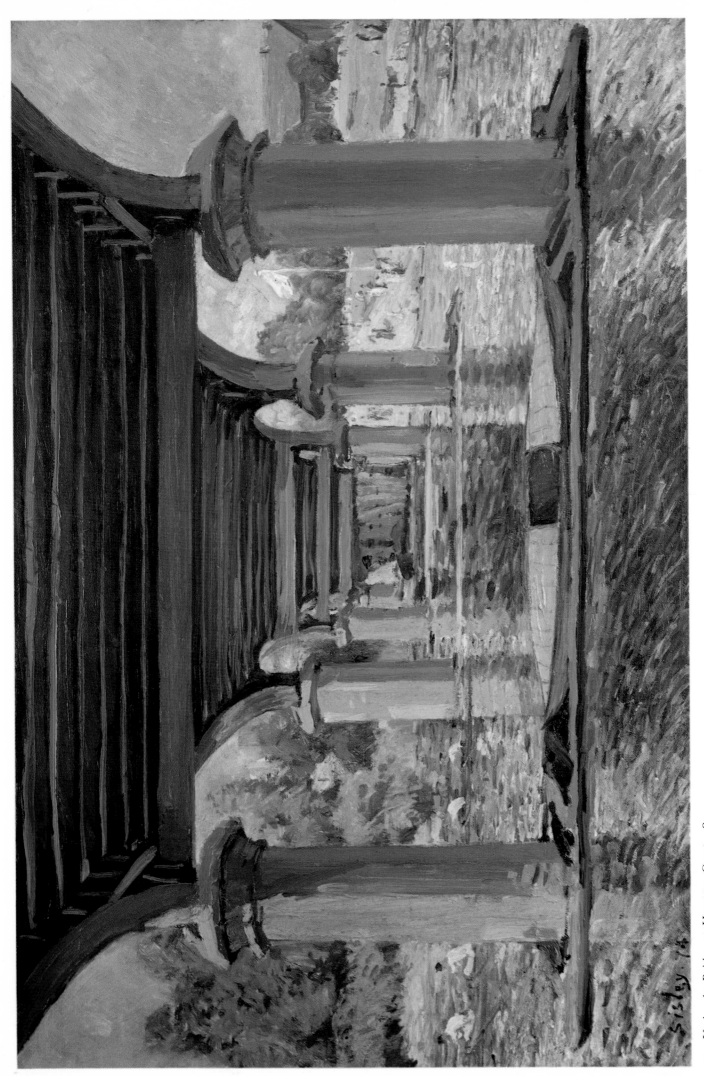

24. *Under the Bridge at Hampton Court.* 1874.
Winterthur, Kunstmuseum

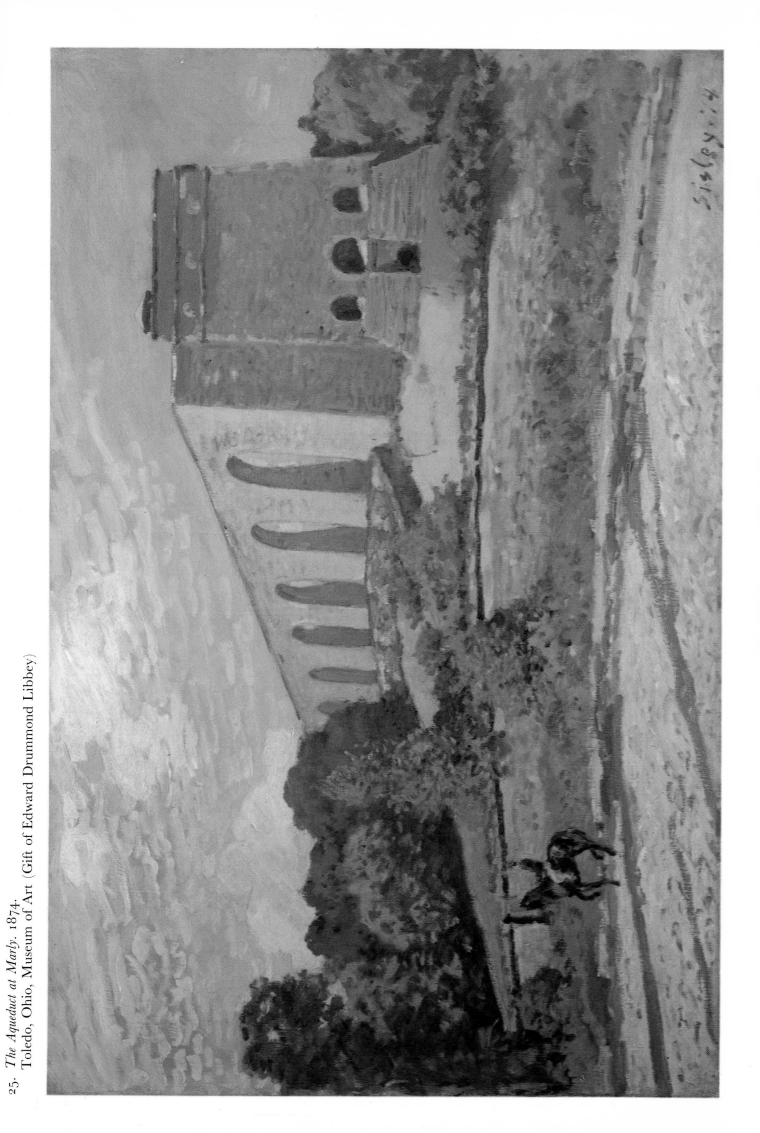

25. *The Aqueduct at Marly.* 1874.
Toledo, Ohio, Museum of Art (Gift of Edward Drummond Libbey)

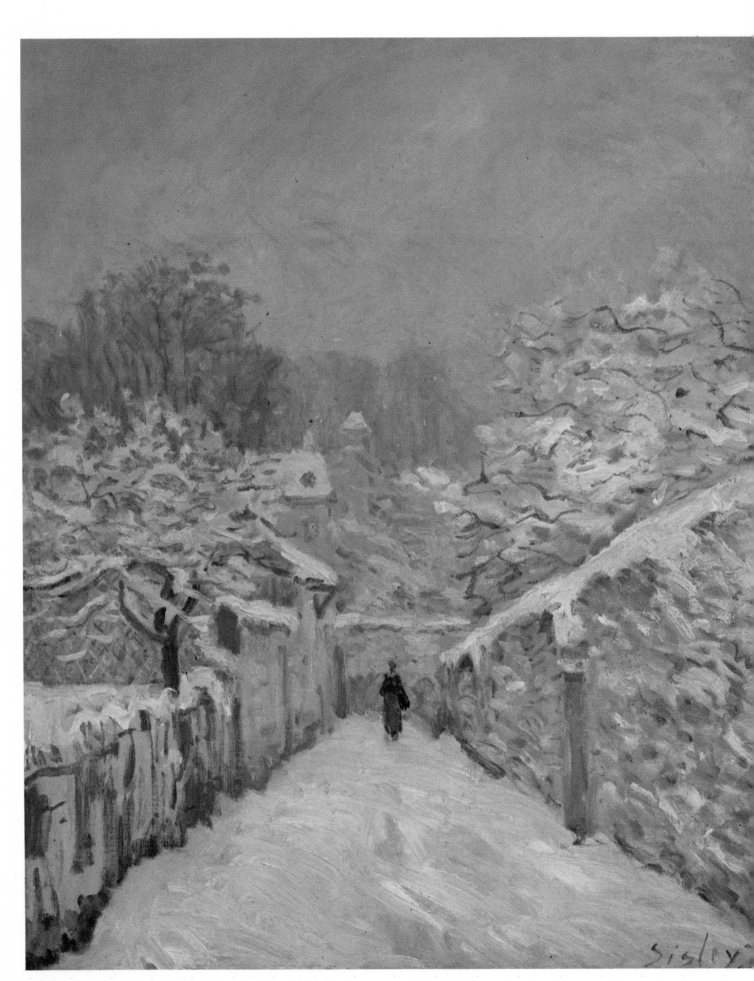

26. *Snow at Louveciennes.* 1878.
 Paris, Louvre (Jeu de Paume)

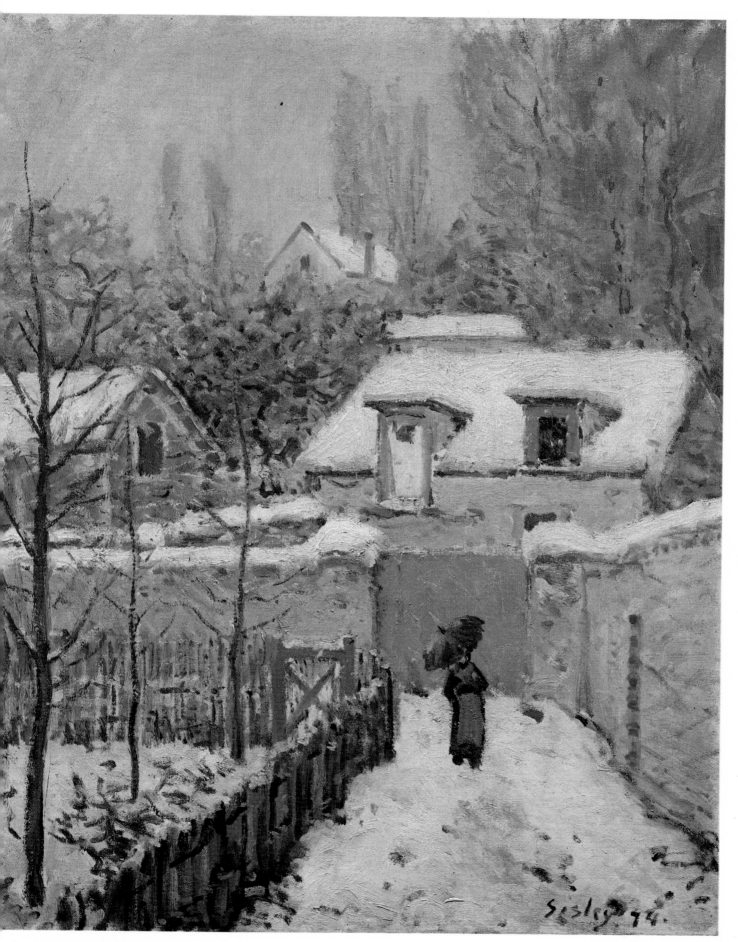

Snow at Louveciennes. 1874.
Washington, D.C., Phillips Collection

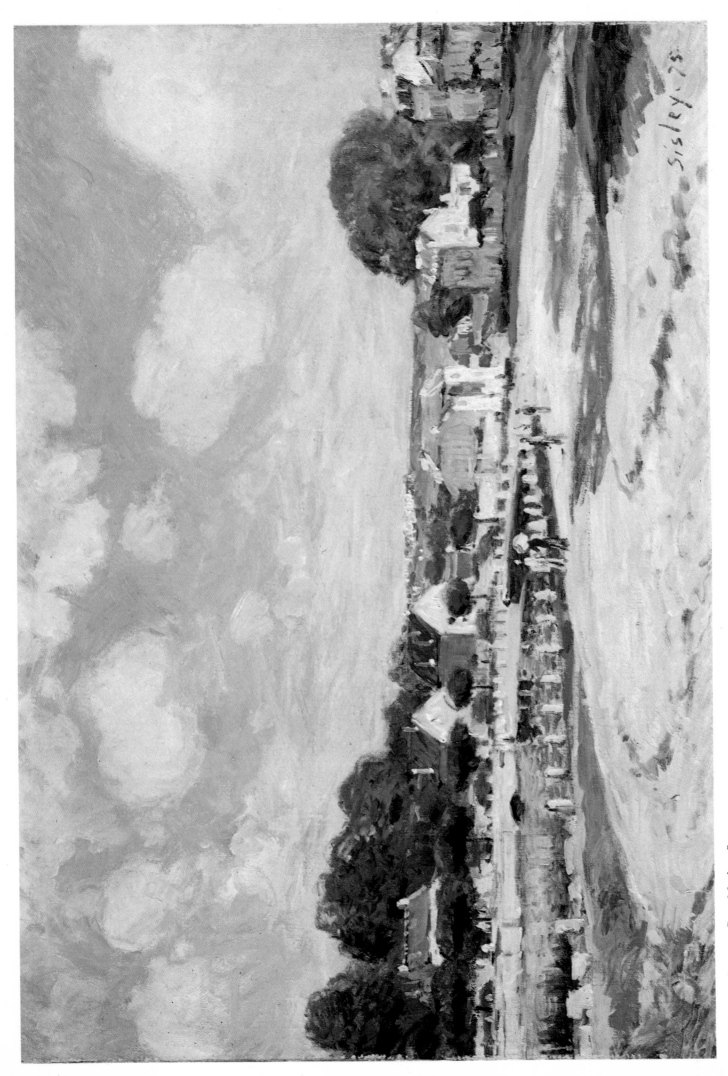

28. *Watering-Place at Port-Marly.* 1875.

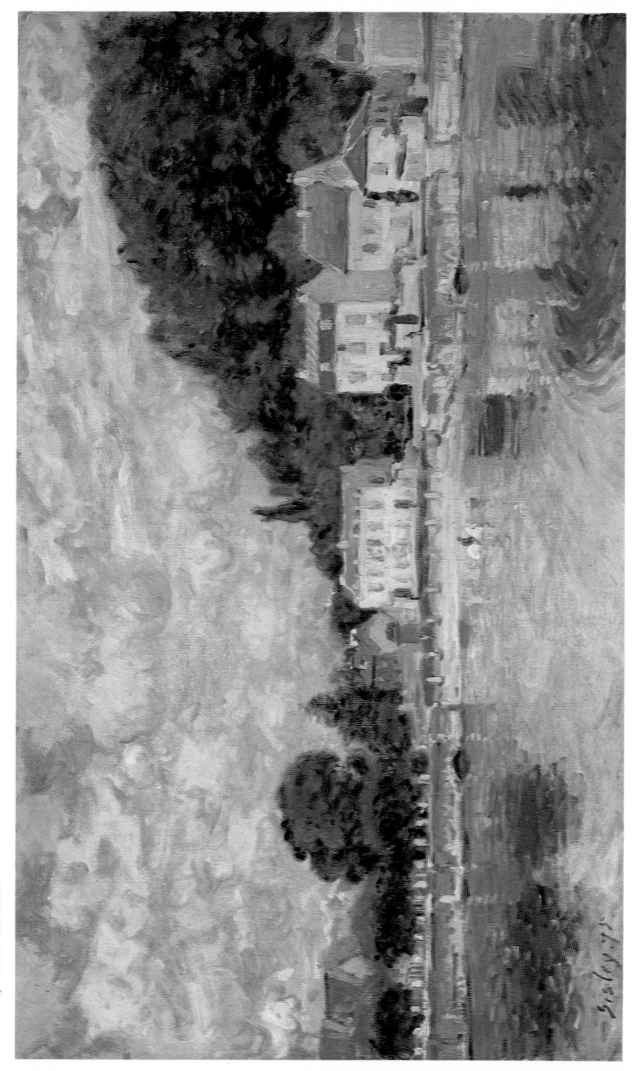

29. *Watering-Place at Port-Marly.* 1875.
Zurich, Bührle Collection

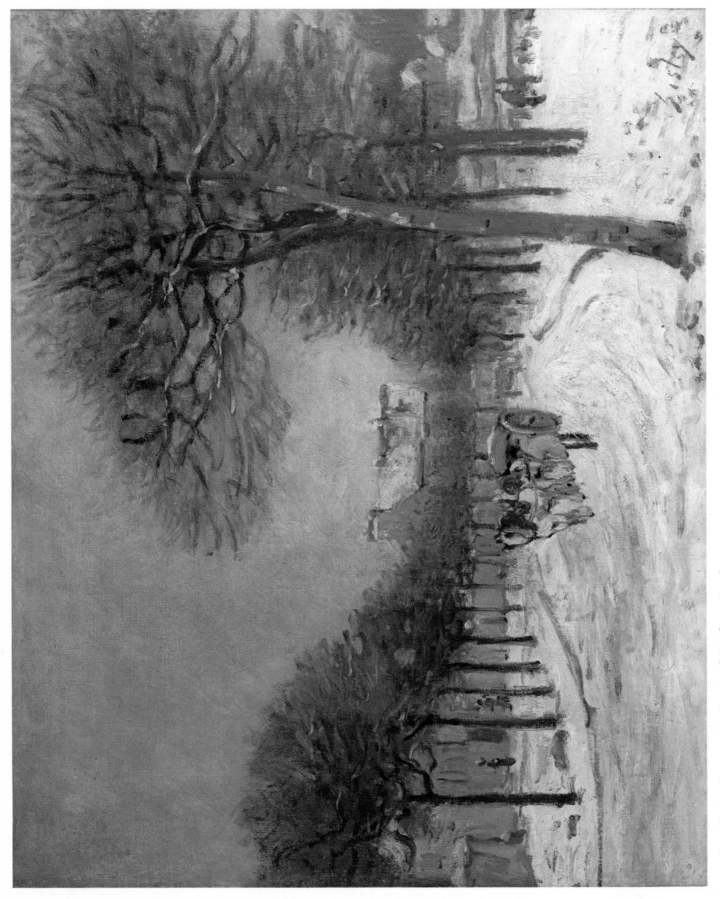

30. *Near Marly: Snow on the Road to Saint-Germain.* 1874–5.

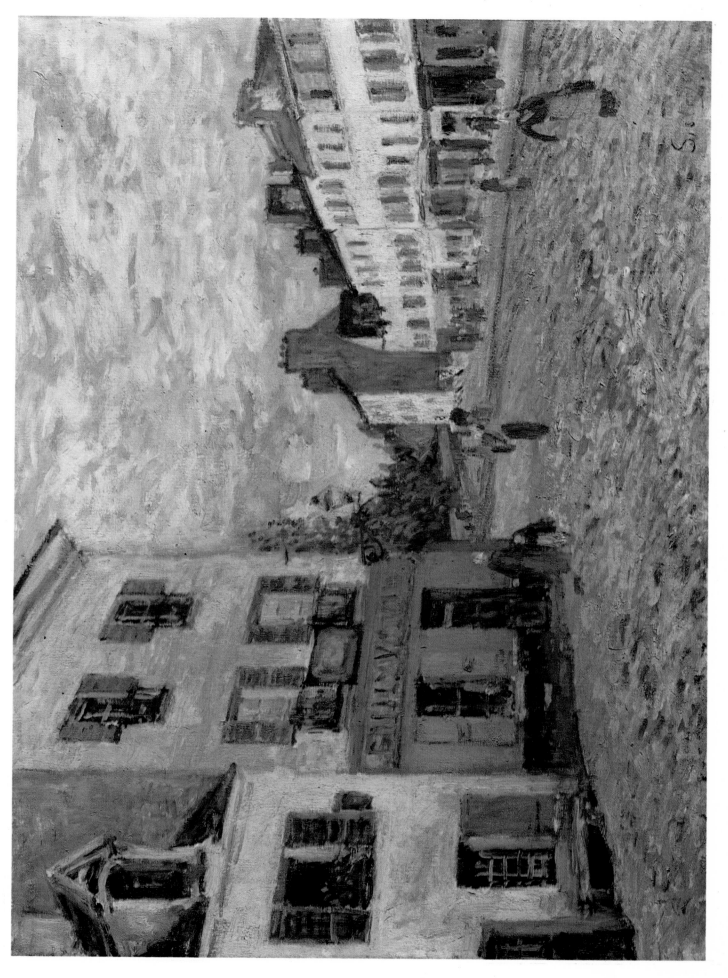

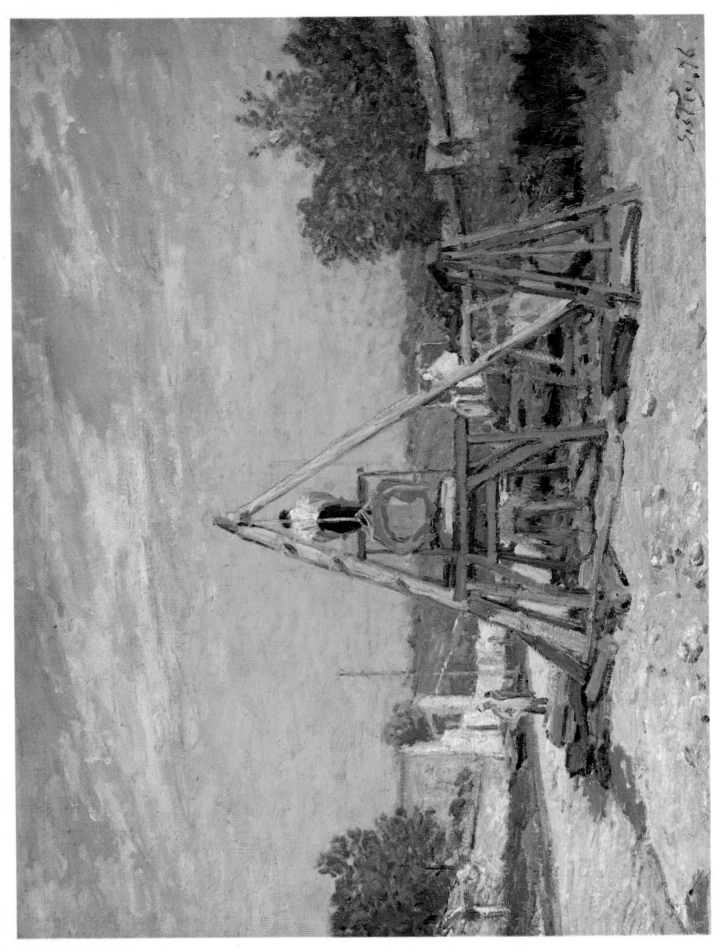

88 *Men Sawing* 1876

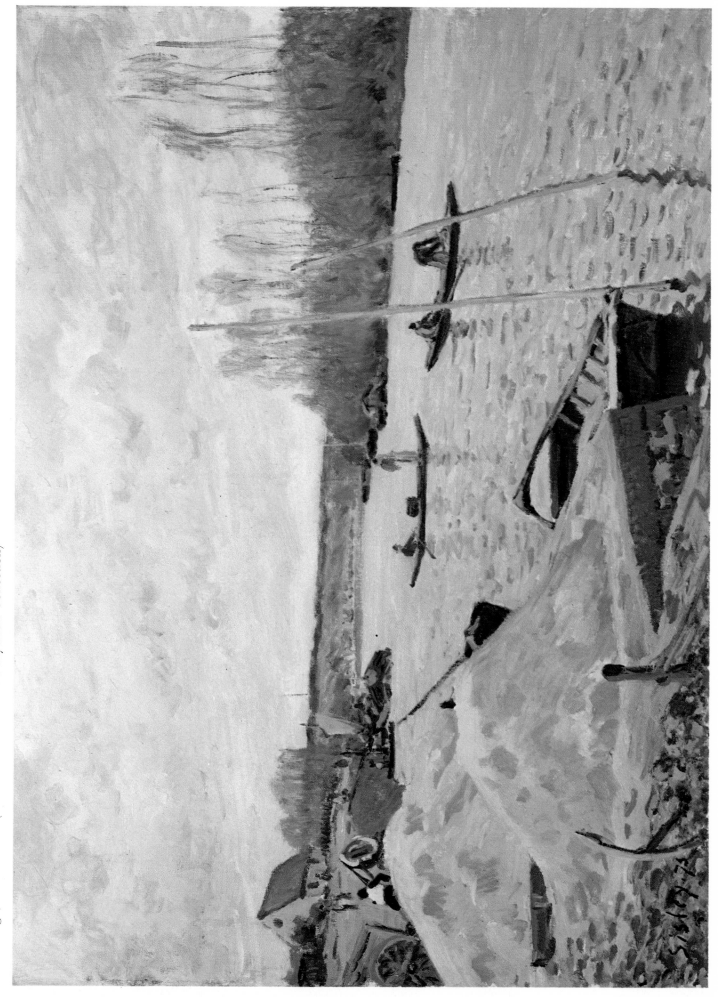

Chicago, Art Institute (Mr and Mrs Martin A. Ryerson Collection)

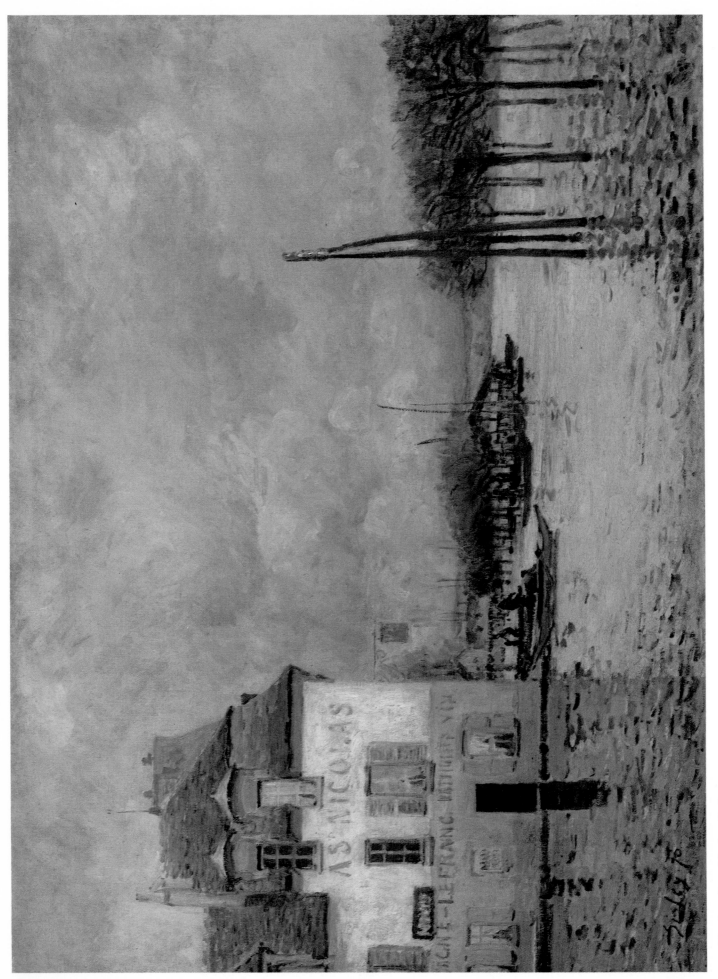

34. *Flood at Port-Marly.* 1876.

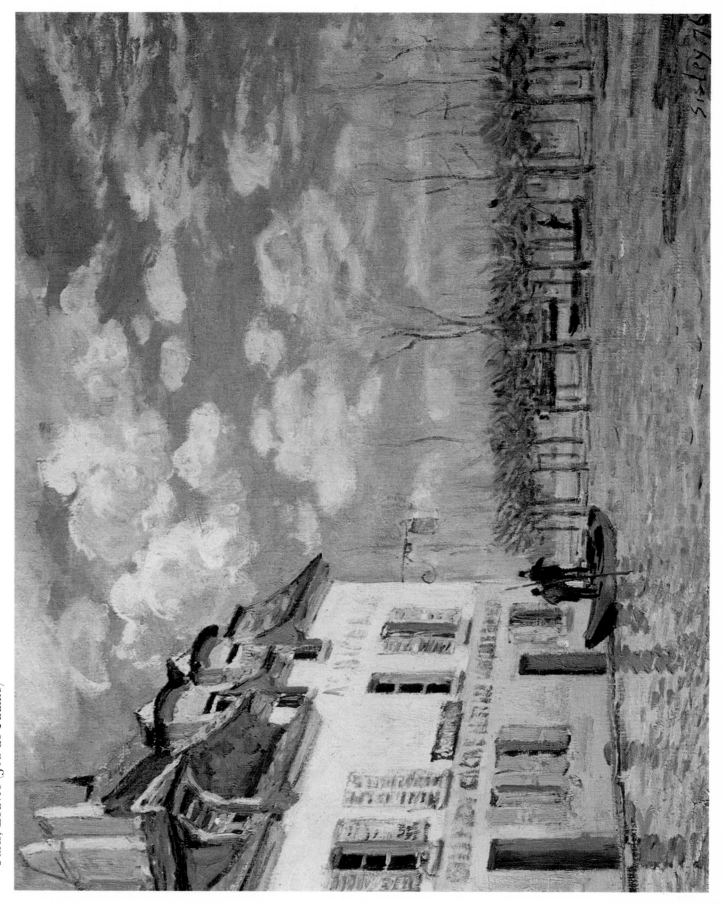

35. *The Boat in the Flood*. 1876.
Paris, Louvre (Jeu de Paume)

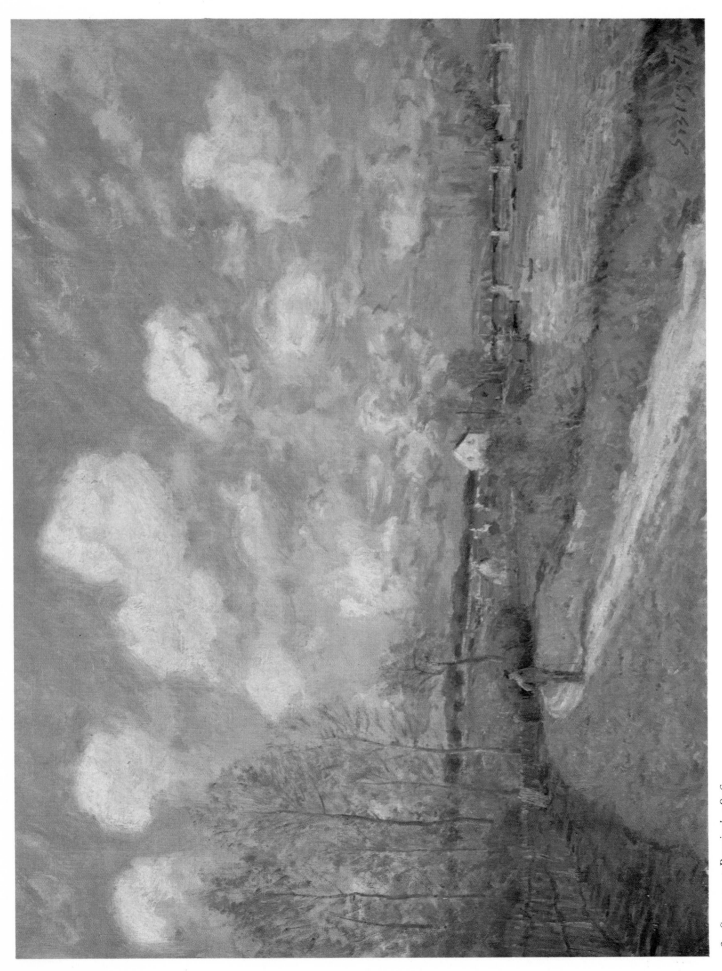

36. *Summer at Bougival.* 1876.
Zurich, Bührle Collection

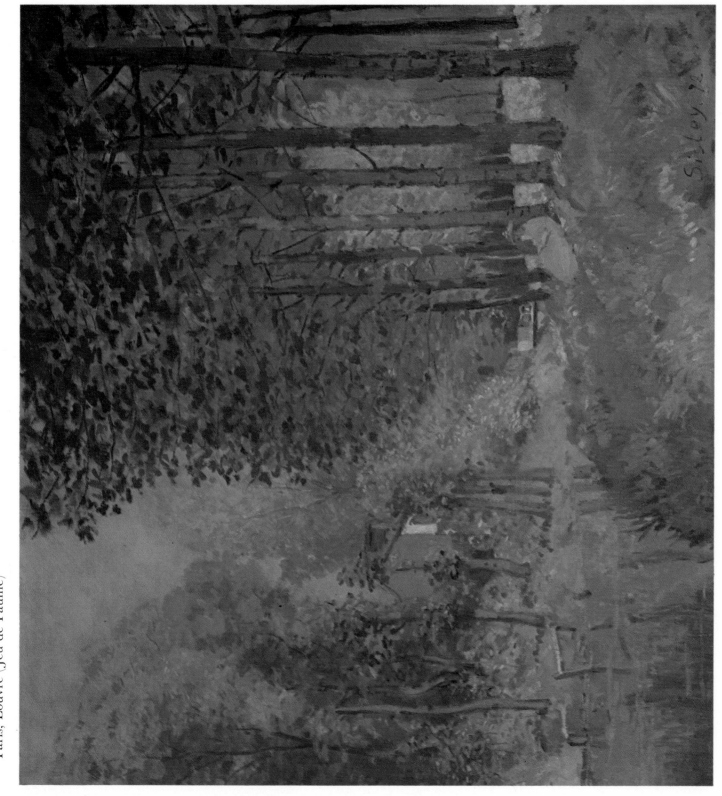

Paris, Louvre (Jeu de Paume)

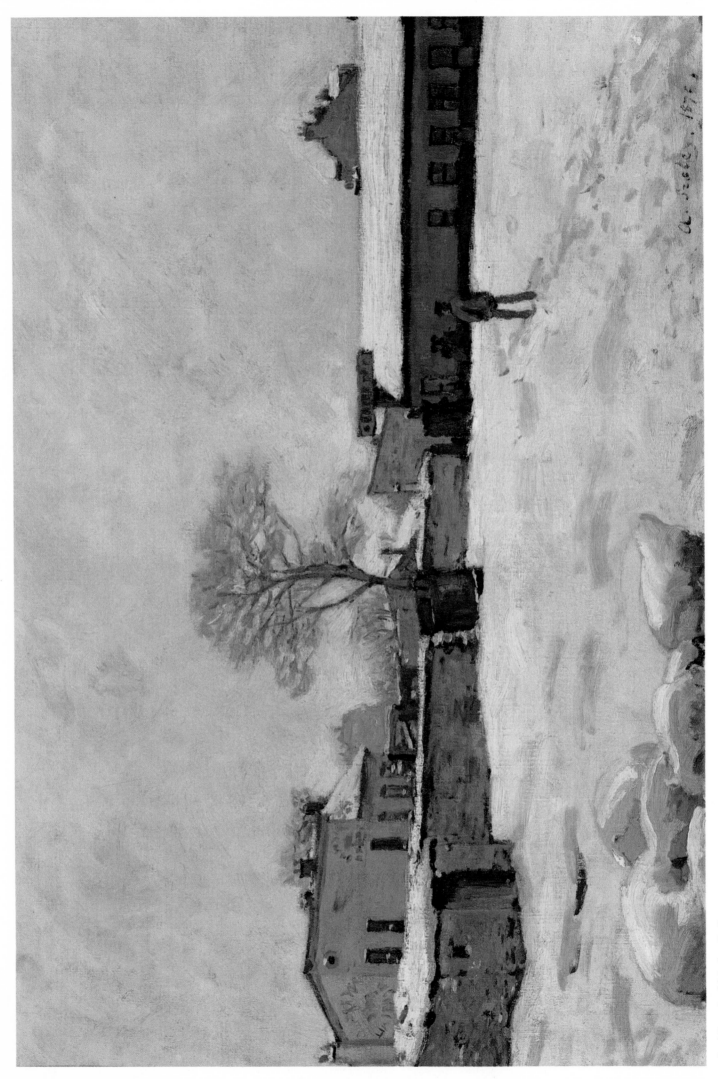

38. 'Sous la Neige'. 1876.
Paris, Louvre (Jeu de Paume)

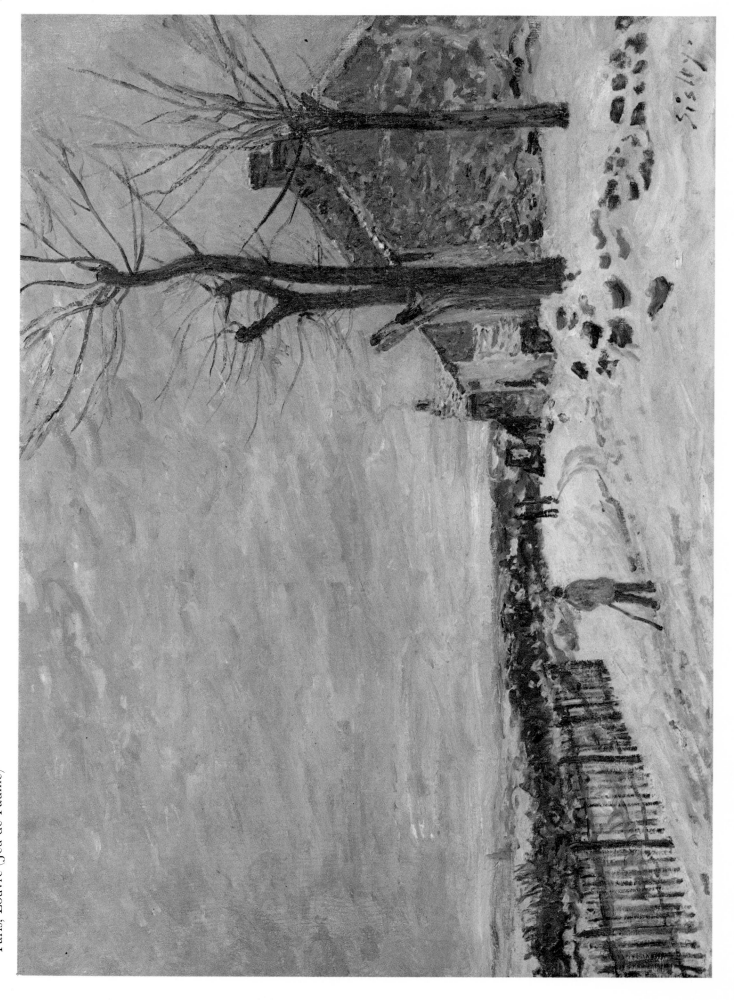

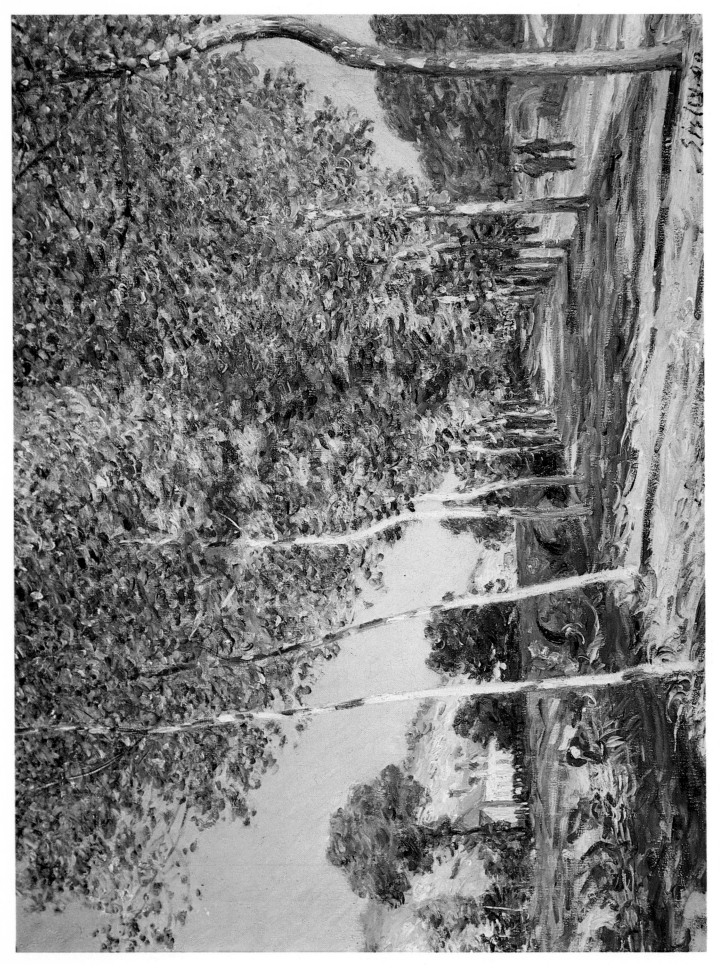

40. *Avenue of Poplars near Moret.* 1890.

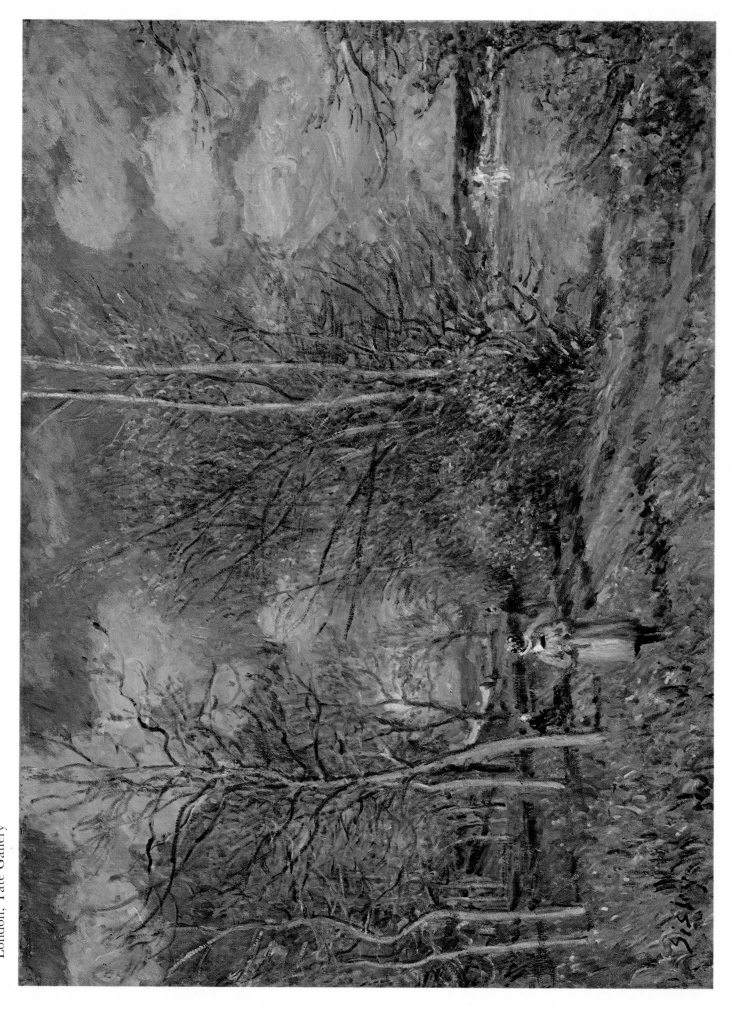

41. *Small Meadows in Spring*. About 1882-3.
London, Tate Gallery

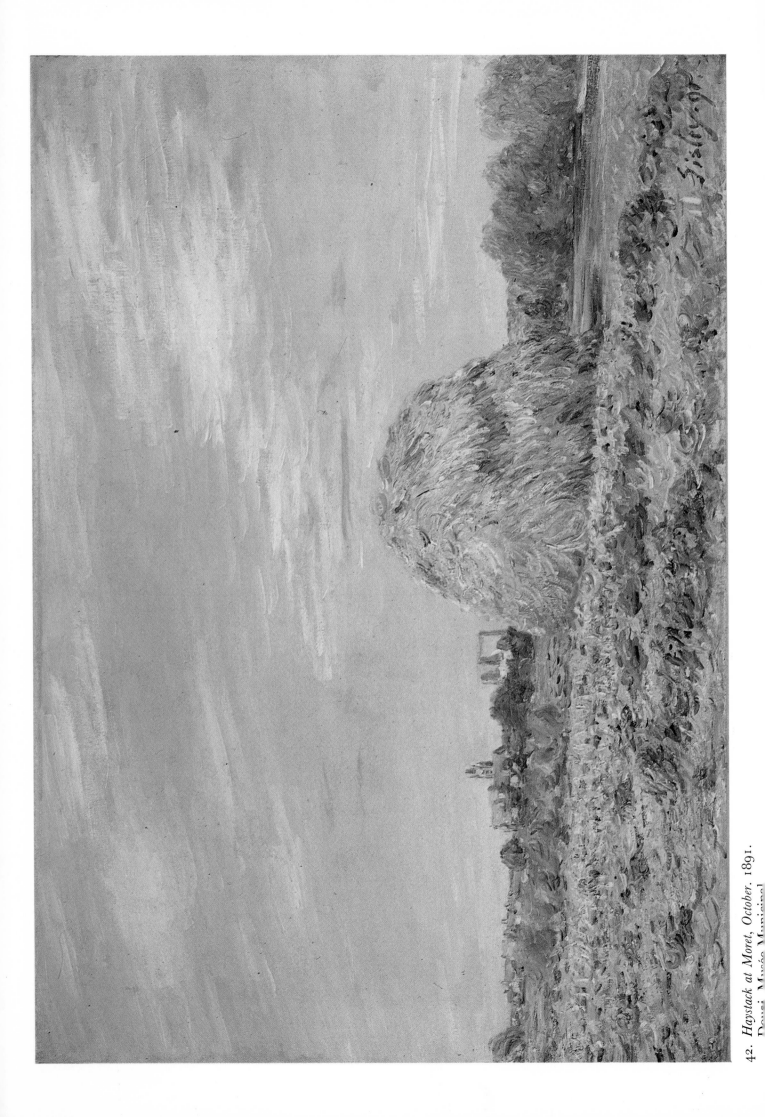

42. *Haystack at Moret, October. 1891.*
Douai Musée Municipal

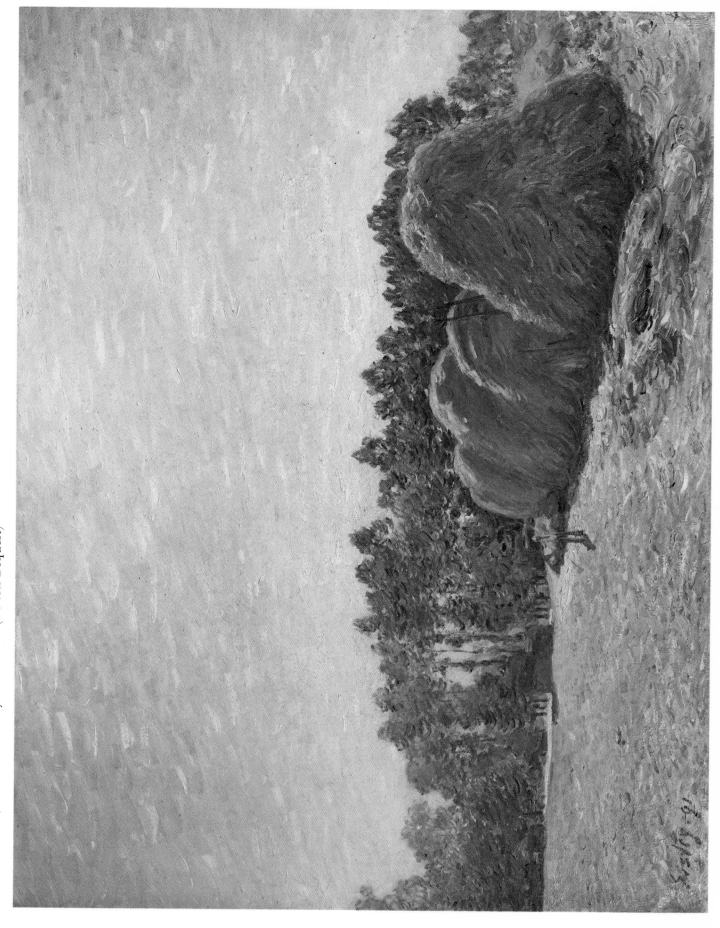

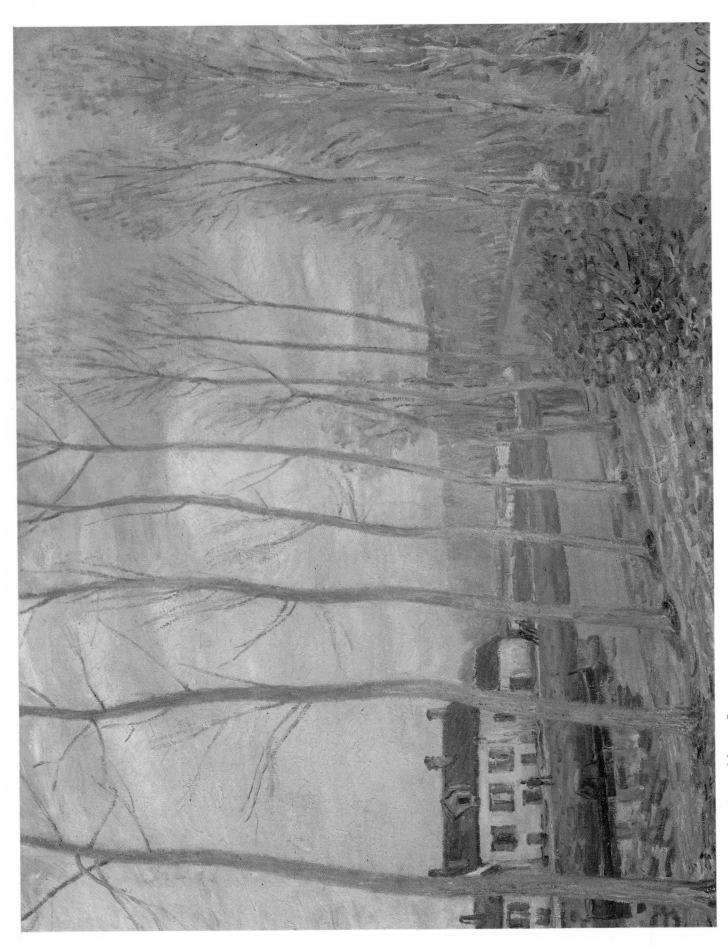

44. *The Canal du Loing at Moret.* 1892.

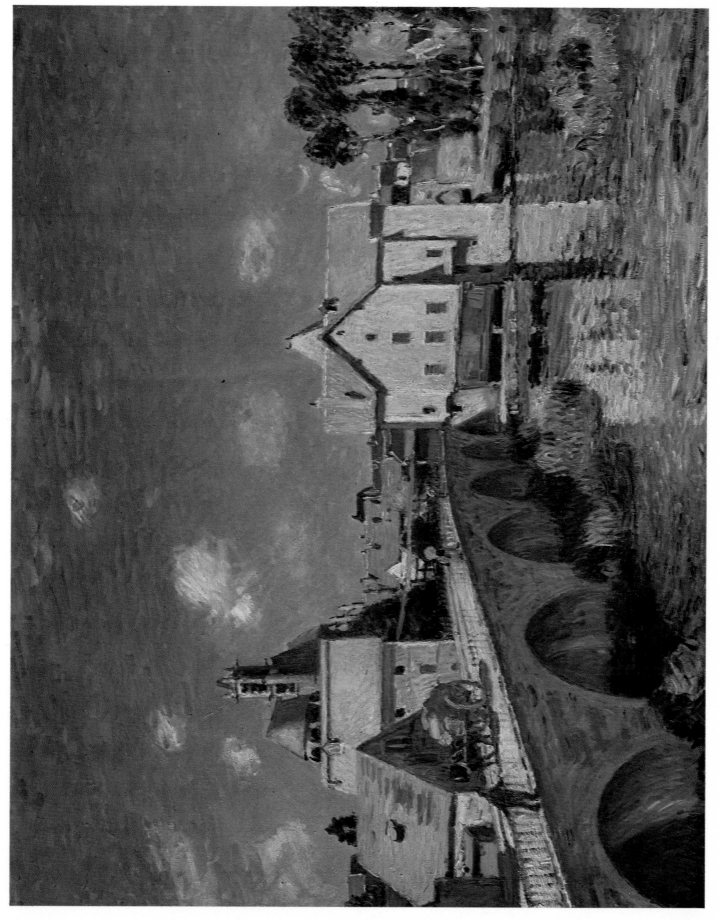

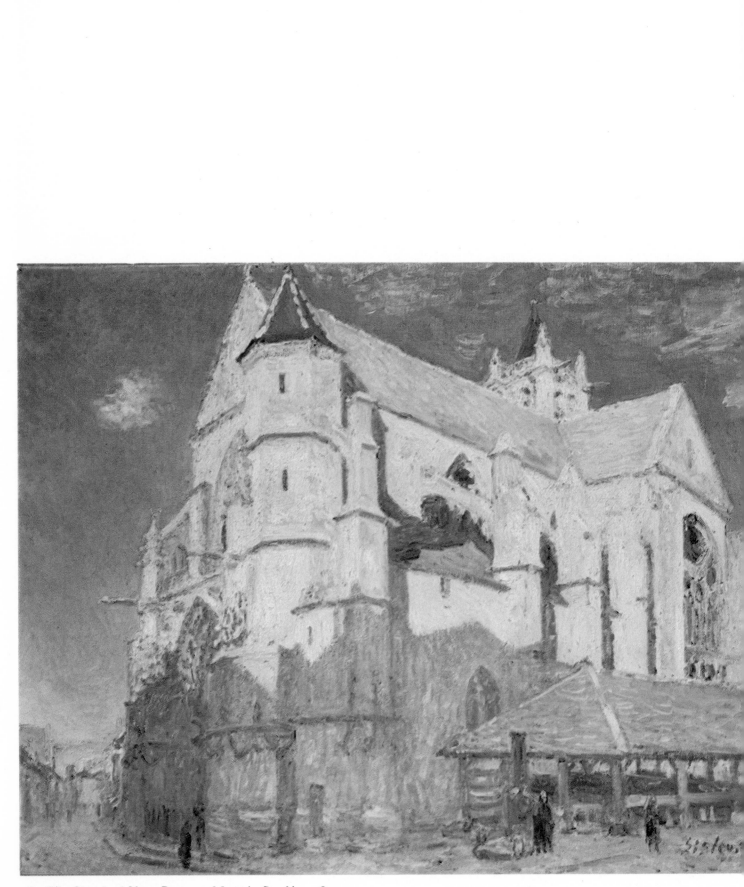

46. *The Church of Notre-Dame at Moret in Sunshine.* 1893.
Rouen, Musée des Beaux-Arts

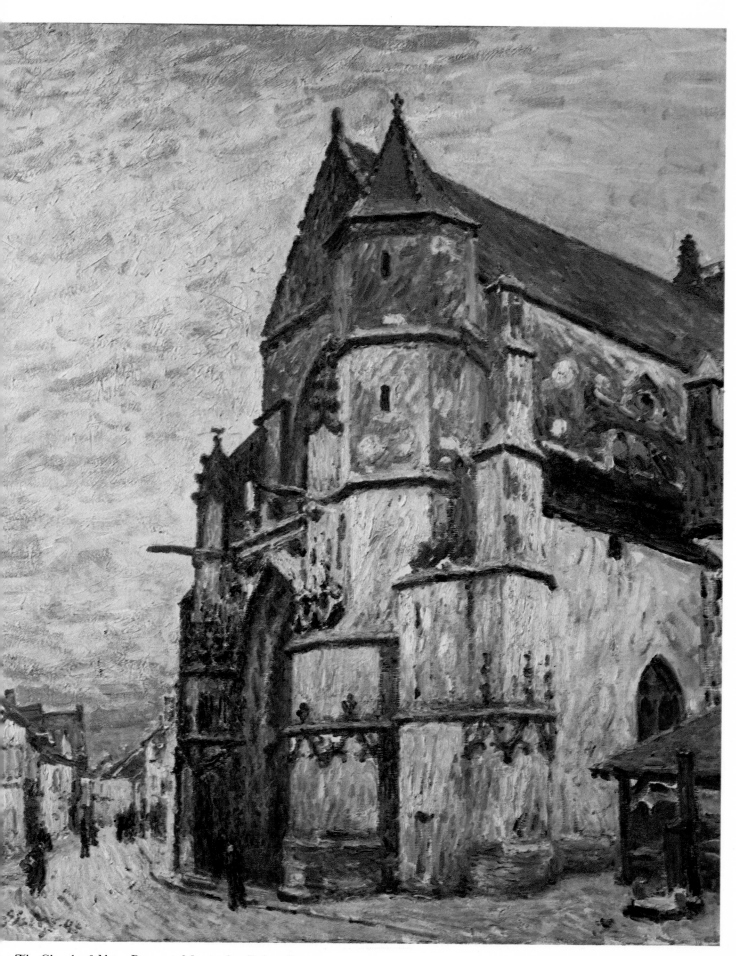

The Church of Notre-Dame at Moret after Rain. 1894.
Detroit, Institute of Arts

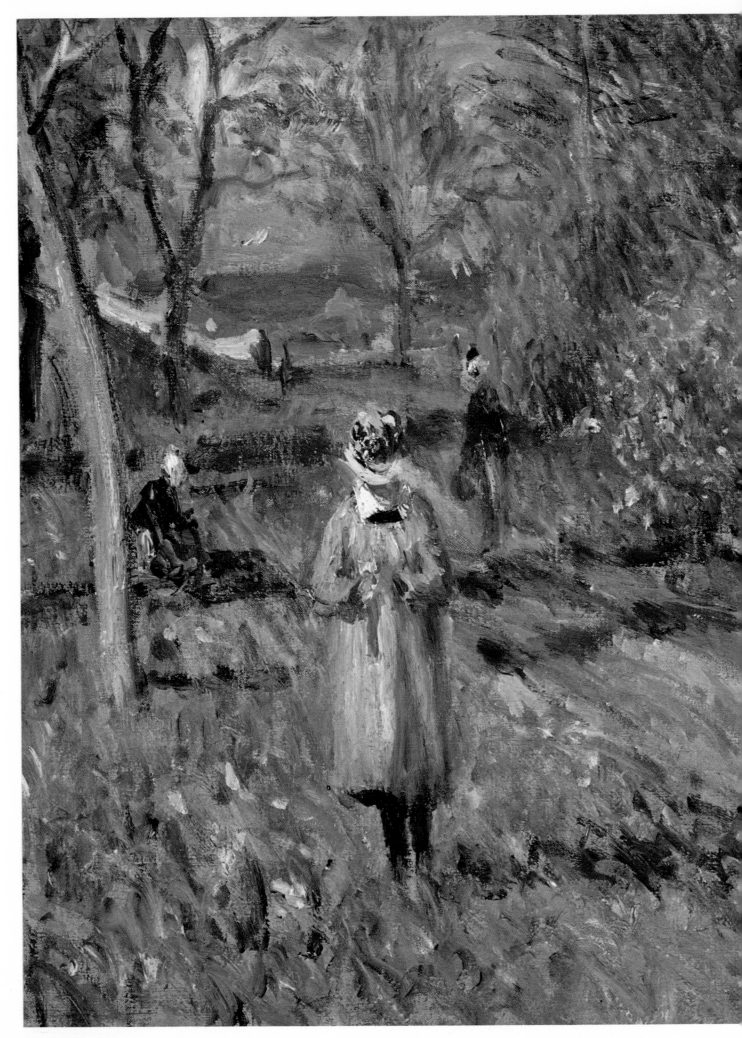

48. Detail of Plate 41